NAMBAN ART

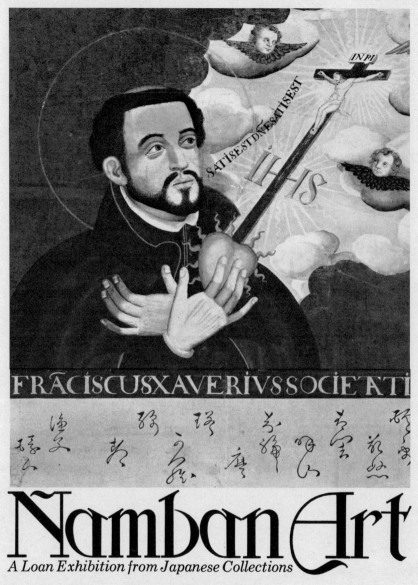

Namban Art

A Loan Exhibition from Japanese Collections

Shin'ichi Tani · Tadashi Sugase

Circulated by the International Exhibitions Foundation 1973

PARTICIPATING INSTITUTIONS

Japan House Gallery, Japan Society, Inc., New York

The St. Louis Art Museum, St. Louis, Missouri

The Honolulu Academy of Arts, Honolulu, Hawaii

CONTENTS

The occasion of an exhibition from Japan is always a happy event, and the one catalogued here is a special cause for joy. Namban art has rarely been seen here in exhibition and never before in so rich and comprehensive collection.

Consisting entirely of loans from distinguished Japanese collections, "Namban Art" was planned in Japan with the full cooperation of collectors, institutions, scholars, and the Imperial Household, and in this country with host institutions and the International Exhibitions Foundation.

It is appropriate here to express our thanks to all who worked so diligently that this important art of Japan might be presented to an increasing and interested American public.

John D. Rockefeller 3rd
Chairman of the Board
Japan Society, Inc.
New York, January 1973

FOREWORD

I would like to express my pleasure in this exhibition of works of Namban art, which is being circulated in the United States of America through the good offices of Mrs. John A. Pope, President of the International Exhibitions Foundation, and consists mainly of objects loaned by the Kobe Municipal Museum of Namban Art.

The collection from the Kobe Museum was formed by the late Mr. Hajime Ikenaga (1891-1955) and is generally acknowledged to be the outstanding one of its kind in Japan, both as to size and quality.

In 1951 I held the position of Director of the Finance Bureau of the City of Kobe, and as such was responsible for the official decision to acquire the collection from Mr. Ikenaga. I felt that it was impera-tive to have these treasures safeguarded for the benefit of future generations.

It is only natural, therefore, that I should have a warm personal regard for the entire collection and I am delighted at the prospect of sharing this pleasure with the people of the United States. It is also my sincere hope that this exhibition may serve further to strengthen the ties of friendship existing between our two countries.

December, 1972

Tatsuo Miyasaki
Mayor of Kobe

ACKNOWLEDGEMENTS

It is with profound pleasure that I write these few remarks preceding the catalogue of the exhibition of "Namban Art" on loan from six of the most distinguished private collections and museums in Japan. This, the first major exhibition of Japanese Art that I have been privileged to organize, will be shown in three leading American galleries, beginning with Japan House Gallery in January 1973. The St. Louis Art Museum and the Honolulu Academy of Arts will also participate in the tour.

The idea for the exhibition, the first of its kind ever to be shown in the West, originated during a trip to Japan in the Spring of 1971 and a first visit to the Kobe City Museum of Namban Art. The director of this delightful museum, Mr. Yasuo Orimo, showed great interest in the proposed traveling exhibition and negotiations were soon concluded.

It is always difficult to thank adequately all those who lend great treasures from their collections for extended periods. Few of the "Namban" screens, potteries, and metal and lacquer pieces have ever left Japan before, and we are therefore particularly grateful to the six distinguished lenders, above all to the Imperial Household Collection.

Mr. Orimo also deserves our deepest gratitude for the many splendid loans from his museum (which are included in the show). We are most grateful to the Mayor of Kobe, the Honorable Tatsuo Miyazaki, and his staff, for their willingness to send their most valuable screens to the United States.

The founder of the Namban Bunkakan in Osaka,

Mr. Yoshiro Kitamura, has helped us with numerous important loans for which we are most grateful. We also wish to thank the following private collectors who contributed generously to the exhibition (for allowing us to include some of their finest possessions): Mr. Akira Fujii, Mr. Ichio Kuga, and Mr. Nagataka Murayama, whose splendid screens showing the "Lepanto Battle" have never before been shown in public.

The exhibition could not have been organized without the cooperation of Professor Shin'ichi Tani, who personally obtained some of the most important loans and who contributed a learned essay, "East Asia and the West," to the catalogue. He and Dr. Tadashi Sugase, Curator of the Kobe City Museum of Namban Art, are responsible for the selection of the seventy-six Namban objects. Dr. Sugase also wrote the Introduction to this catalogue, as well as the individual description of most items. We thank both these scholars for their constant supervision of this exhibition.

Mr. Kenji Adachi, Commissioner of the Bunka-cho (Agency for Cultural Affairs), was instrumental in granting the necessary export permission for the loans, and we wish to acknowledge his assistance with profound thanks.

The International Exhibitions Foundation is happy to note here that His Excellency Nobuhiko Ushiba, the Ambassador of Japan, has kindly agreed to sponsor the "Namban Art" exhibition during its tour. I am personally most grateful to him for everything he has done to assist me as an old friend and

fellow student from Heidelberg days. The Cultural Counselor of the Embassy, Mrs. Taeko Shima, was also very helpful.

Among the many staunch friends who have made this exhibition possible, we wish to single out Mr. and Mrs. Joe D. Price, who gave unstintingly of their time and energy. We are also grateful to Mr. Meredith Weatherby for much-needed advice in regard to this catalogue, and to our old friend, Mr. Junkichi Mayuyama.

Together with the Foundation's staff, Dr. and Mrs. Edgar Breitenbach took over the complicated editing of the manuscript which was translated largely through the efforts of Mr. Shigetaka Kaneko and Mr. Hiroaki Sato. We owe the original design and typography to Mr. Kiyoshi Kanai. The Meriden Gravure Company undertook the printing job under difficult circumstances, and we wish to thank Mr. Harold Hugo and Mr. William J. Glick for their unflagging cooperation.

As always we owe a debt of gratitude to the Directors of the galleries participating in the tour, none more than Mr. Rand Castile, Director of the Japan House Gallery, and his assistant, Mrs. Maryell Semal. Both have done everything possible to display the objects in the most effective and, at the same time, the safest way, and the unusual interest taken by the press is due to their untiring efforts. Japan House has, in fact, assumed a large role in bringing about this, their fifth exhibition, and we wish to thank all concerned with this project. We are also grateful to Charles E. Buckley, Director of the St. Louis Art Museum, and James W. Foster, Director of the Honolulu Academy of Arts.

The project is supported by a grant from the JDR 3rd Fund, and we are happy to acknowledge all the help rendered by Mr. Porter McCray, its Director. Mr. John D. Rockefeller 3rd has kindly contributed a foreword to this catalogue, and we are most grateful to him.

I cannot close these pages without mentioning the encouragement I received from my husband, both during the conference in Japan and the countless preparations here. Dr. H. P. Stern, Director of the Freer Gallery of Art, gave freely of his time and counsel, and we deeply appreciate the assistance of both scholars.

It is my hope and belief that the present exhibition of "Namban Art"—the art of the period of Portuguese residence in Japan during the 16th and the first half of the 17th centuries—is an initial step in the study of this material in the United States. It is a fascinating phase in the history of Japanese art during the Momoyama Period; and the outstanding and extremely rare examples in the exhibition will, hopefully, stimulate further studies in both East and West. If we join forces now, we will surely develop a greater understanding of "Namban Art."

Annemarie H. Pope
President
International Exhibitions Foundation

LENDERS TO THE EXHIBITION

Imperial Household Collection

Mr. Nagataka Murayama

Mr. Akira Fujii

Mr. Ichio Kuga

Kobe City Museum of Namban Art, Kobe, Japan

Namban Bunkakan, Osaka, Japan

I. Early European Visitors to Japan

In 1541 a Portuguese trading ship was cast ashore at what is now Oita Prefecture in Kyushu, and received the protection of Otomo Yoshiaki, the feudal lord ruling that district.[1] Two years later, another Portuguese ship came adrift off the coast of Tanegashima, an island located south of present Kagoshima Prefecture, which is also in Kyushu, and matchlock guns were given to Shimazu Takahisa, the *daimyo* of Satsuma (Kagoshima).[2] The importance of these two events, as confirmed by Japanese documentary sources, is that they served to open up official contact between Japan and Europe. However, the first European to come to Japan for the express purpose of introducing European culture was the Spanish Jesuit father, Francis Xavier, who landed in Kagoshima on August 15 (the day of the Ascension of the Virgin) in the year 1549. Xavier, the Apostle of the Indies, was sent by the Portuguese King John III on a missionary journey to the East. At Malacca, the capital of the kingdom of Malacca on the Malay Peninsula, he happened to meet a Japanese named Yajiro (his surname is unknown), who spoke the Portuguese language and under whose guidance he came to Japan aboard a Chinese trading ship. Granted permission by the Lord of Shimazu Takahisa to engage in missionary work, he first visited the Kyushu district and then went up to Kyoto, at that time the capital of Japan. Subsequently he returned to Kyushu, and left Japan after a sojourn of sixteen months.

From this time on, the civilization of southern Europe, in particular that of Spain and Portugal introduced into Japan by visiting Jesuits and Portuguese traders, was to exert great influence on Japanese culture. It is thought that by 1582 the number of Japanese that had embraced Christianity had risen to 150,000. In that year, delegates to the Pope in Rome were sent by three feudal lords of Kyushu; in 1613, Date Masa-

mune, the feudal lord governing what is now Miyagi Prefecture in northern Japan, also sent ambassadors to the Pope. A Japanese translation of an abridged version of the *Guia de Pecadores (The Sinner's Guide)* was published in 1599 at Nagasaki.[3] (Incidentally, it was through this book that the word "Asia," used by Europeans to refer to Eastern countries, became known to the Japanese.)

Christianity thus spread very rapidly in Japan for several decades after Xavier's visit, while at the same time European goods were brought in on trading vessels. Interest in European culture was enhanced, and to some extent European manners and customs were gradually absorbed into the life of the rulers, the local feudal lords and the well-to-do. As far as the arts were concerned, the first items to be circulated were religious paintings and other devotional objects, as well as books used in the liturgy of the Catholic Church; these were followed by books and secular pictures to aid in the understanding of European culture and thereby inspire the Japanese in the Christian faith. The chief impetus to the rapid rise and development of Japanese painting in the European style in the late 16th and early 17th centuries, however, was provided by the *seminarios* that visiting priests established in various parts of the country for training Japanese Jesuits. The *seminarios*, of course, were schools for educating future clergymen, but the students were also given instruction in the painting of religious pictures. Thus a body of artists was gradually created who expressed themselves in a European manner, although the number of teachers and students was limited, as was the supply of materials available. Nevertheless, it was a remarkable phenomenon in the history of Japanese painting, which for ten centuries had remained almost exclusively within the sphere of influence of Chinese art.

Hostility towards Christianity on the part of the rulers of Japan, and the subsequent bitter rivalry

between Portugal, Spain, the Netherlands and Britain to capture the Japanese trade, led the Shogun Tokugawa Hidetada to ban the Christian faith in 1613. His successor, Tokugawa Iemitsu, expelled the Portuguese and Spanish visitors, and closed the country to foreigners in 1639. As a result, the development of art in the European manner was suspended in Japan; furthermore, the majority of works in this category, whether imported or created in Japan, were destroyed or discarded, leaving us today with only a handful out of the tens of thousands of objects that once existed. The examples shown in this exhibition are discussed in detail elsewhere in this catalogue by Dr. Tadashi Sugase.

II. China and West Asia

While Japan consists of an archipelago isolated from the mainland by wide stretches of open sea, China, situated in the eastern part of the continent of Asia, is contiguous to the continent of Europe. It is therefore quite feasible that China had contact with the European continent since prehistoric times; there is archaeological evidence to support her close connections with western countries. The official history of China records that ambassadors from West Asian countries visited the Chinese capital Ch'ang-an during the reign of the Emperor Wu Ti, a Han Dynasty ruler (141-87 B.C.);[4] that Han Ying was dispatched in 97 A.D. to Ta-ch'in (the present Egypt and Syria) along a land route through Central Asia;[5] and that the ambassador of the Roman Emperor Marcus Aurelius reached the Chinese capital Lo-yang by a sea route.[6] The facts suggest that the Greek, Hellenistic and Roman cultures were transmited gradually to China by West Asian tribes acting as intermediaries. Many different cultures of West Asia were thereafter introduced to China by way of Central Asia, and were absorbed most eagerly during the Sui and T'ang Dynasties (581-907 A.D.).

Indeed, it may be claimed that one of the main characteristics of the T'ang Dynasty, which along with the Han Dynasty represented a peak in Chinese cultural history, was its acculturation of West Asian civilizations. The first experiment in suggesting three-dimensional solidity in Chinese paintings was by Wei-ch'ih I-sêng, an immigrant either from Tocharia (in what is now northern Afghanistan) or from Khotan (a city-state in East Turkistan), who was summoned by the T'ang Emperor T'ai Tsung during the Chên-kuan era (627-649 A.D.) to serve as a court artist.[7] Zoroastrian, Manichaean, Islamic, Brahman and Nestorian chapels were constructed in the capital Ch'ang-an and in other large cities during the T'ang Dynasty. There were also settlements inhabited by missionaries, merchants and military personnel from West Asian countries. These facts offer proof that West Asian cultures, which derived from Mediterranean cultures and from Persian culture in particular, were much in favor in China at the time.[8]

It is generally accepted that West Asian cultures reached China by a land route via Central Asia, as is shown by the voluminous reports brought back by distinguished scholars from expeditions to Central Asia. The first such expedition was made in 1900 by Sir Aurel Stein of England, who was followed by Albert Grunwedel and Albert August von Le Coq of Germany, Peter Kuzmich Kozlov of Russia, Sven Hedin of Sweden, Paul Pelliot of France, etc. In more recent times, however, Chinese archaeologists, historians and art historians tend to emphasize the fact that West Asian cultures were introduced to southern China by sea routes from India, Persia and Arabia, which once constituted an Islamic empire. As early as the eighth century, Chinese ships transported ceramics to India, Persia and Egypt, a fact that probably accounts for the mention of Kuang-chou, Ch'üan-chou, Yang-chou and many other ports of trade in 9th-century Arabian books on geography.[9] Especially during and after the

Sung Dynasty, communication with the West depended almost entirely on sea routes.[10]

Indian priests came to Ch'üan-chou in Fukien via Malaya in 558 and 565, and established Buddhist temples there. Four Islamic missionaries from Arabia came to Ch'üan-chou during the Wu-tê era (618-626),[11] one of whom journeyed to Kuang-chou in Kuangtung and to Yang-chou in Kiangsu in order to make proselytes. At the same time, Arabian traders began to visit Ch'üan-chou and Kuang-chou; official envoys from the Islamic empire came in 651. Arabian settlements emerged at the two port towns, and some of the Arabian residents there were nominated to Chinese governmental posts.[12] By then, adherents of Mohammedanism, Judaism, Christianity and other foreign religions at Kuang-chou already numbered 12,000.[13]

It was during the Sung and Yüan Dynasties (960-1367) that Kuang-chou and Ch'üan-chou enjoyed the most thriving activity as ports of foreign trade. Foreigners from Malacca, India, Persia, Arabia, Italy, as well as other regions, came in increasing numbers to live there. Ancient Chinese manuscripts refer to Arabs and Persians, but in fact both these peoples belonged to the country and culture of Persia, or what is now Iran. Hence it will be seen that Iranian culture penetrated southern China, as is further proved by surviving artifacts. In addition to Chinese tea, sugar and fabrics, the main export goods were ceramics and porcelain objects. Such pieces have been excavated in quantities in various parts of what is now the Middle and Near East. It goes without saying that with Iranian culture as the medium, the Mediterranean and European elements included in it were absorbed unconsciously into Chinese culture. That is to say, the mainland of East Asia was the recipient of European culture at a much earlier period and to a far greater extent than was Japan.

Western historians emphasize the discovery of the West Indies by Christopher Columbus in 1492 and of the sea route to India by Vasco da Gama in 1498. In fact, however, the route had been opened earlier by Arabian merchants. On the Chinese side, too, Chang Ch'ien in 1415 and Chêng Ho in 1417 traveled to the east coast of Africa across the Indian Ocean and to the Persian Gulf respectively.[14] Portugal and Spain vied for Far Eastern trade along this already known route. Portuguese ships reached Ceylon in 1505 and Malacca in 1509. They finally arrived at Chang-chou (Fukien) in 1513, then at Kuang-chou in 1517, whereupon trade was opened up between China and Portugal. Francis Xavier's knowledge of Japan, which he obtained in China at this period, probably led to his visit there in 1549.

III. Namban

Stimulated by the Sino-Portuguese trade which had begun in 1513, the Netherlands and England soon followed suit. In about the year 1600 these European countries began to establish their East India Companies, with licenses issued by their respective sovereigns. The main exports from China were ceramics. Evidently, there were enormous quantities of Chinese ceramics exported to Europe, as the Dutch East India Company's records show more than sixteen million pieces shipped between the years 1602 and 1682.[15]

Although European merchants visited China earlier than Japan, the Jesuit missions in China began later than in Japan. Xavier landed at Kuang-chou in 1552, but his death soon thereafter prevented him from engaging in missionary work.[16] The first member of the Society of Jesus to visit China through official channels was the Italian, Matteo Ricci (1552-1610), who arrived at Kuang-chou in 1583. He went to the capital, Peking, in 1601 and saw Emperor Shên Tsung; here he remained until his death. Another Italian Jesuit, Giovanni Niccolo, who sailed on the same ship as Ricci and reached Japan the same year, won fame not only as

a missionary but as an instructor of Japanese painters in the use of European styles at his Christian school. Ricci has his place in Chinese history as a transmitter of the European natural sciences. This is borne out by the fact that in 1607 his Chinese disciple, Hsü Kuang-ch'i (1560-1634) translated Euclid's geometry in six volumes.[17]

It should be noted that the Japanese and Chinese reacted very differently to the arrival of European missionaries and merchants, which occurred at approximately the same time in both countries, just as they reacted differently to exposure to the Christian faith and Christian culture. As we have already seen, China had accepted Persian and Islamic cultures from West Asia even before she encountered Christianity, and through them she had learned something of the Greek, Roman and Byzantine cultures of Europe. There had been many foreign residents from West Asian countries who had established Christian and Islamic places of worship for themselves in the major cities. The Chinese people had thus maintained international relations for over two thousand years. As a result, they did not find fresh interest in the renewed 16th-century impact of Christianity and European trade, unlike the Japanese, for whom it was a new experience. Although Jên Hung-chün states that no natural sciences, as defined by Francis Bacon in his *Interpreter of Nature*,[18] existed in China prior to the arrival of Matteo Ricci, indigenous natural sciences had flourished there since the earliest times. Furthermore, in the development of her humanistic sciences China could easily hold her own with West Asia and Europe.

In the field of plastic arts in particular, only Egypt and Mesopotamia can claim an older history; but while these came to an end, Chinese art has developed continuously over the centuries. Already during the T'ang Dynasty Chinese art had reached such a level of perfection that it was beyond significant influence from any outside country. The afore-mentioned technique of the painter Wei-ch'ih I-sêng could only gain partial acceptance. The introduction of Christian art and European secular art in the 16th century was no more than the influx of a small stream into a large river. In 1715 the Italian Jesuit, Giuseppe Castiglione (1689-1766) was appointed court artist in Peking by Emperor Shêng Tsu;[19] however, he assumed the Chinese name of Lang Shih-ning, whether willingly or not, and was prohibited from painting in Western oils and in a purely Western style. This would indicate that Chinese officialdom, as well as the Chinese people, held native painting techniques in higher esteem. His method of oil painting, therefore, had only slight influence on Chinese art. Probably the Chinese, with their firm belief that painting was essentially an art in two dimensions, did not want to give three-dimensional expression, that is, a cubic effect, to their painting. In contrast, the Japanese people were deeply impressed by the three-dimensional effect of European painting and soon began to imitate it. They also greeted European manners and commodities wholeheartedly, with admiration and respect. This underlies the fundamental difference between China and Japan in regard to their acceptance of European culture.

The Portuguese and Spanish who began to visit Japan in the middle of the 16th century, and the Dutch and British who followed in their wake, were collectively referred to as "*Namban-jin*" by the Japanese. The European paintings they brought with them and the Japanese works modeled on these were called "*Namban-ga.*" The terms mean literally "southern barbarians" and "paintings of southern barbarians" respectively. However, these terms were coined and used almost automatically, spontaneously and with no malice intended. The Chinese classic, *Li-chi*, collated in the first century B.C., used the term "*Nam-fan*" (pronounced in Japanese "*Namban*") to indicate foreign countries and peoples south of China proper. The *Chou-li*, written in the first century A.D., also referred

to foreign countries to the south as *"Fan-kuo"* (barbarian states or countries). The Chinese thereafter continued to use the expression *"Nam-fan"* in reference to Southeast Asian countries and to the peoples of India and Indonesia. Certainly, China had a far higher cultural level than these southern countries and thus felt entitled to refer to them as "barbaric." This usage was adopted by the Japanese during the 10th century in the Heian period, and the term was thereafter applied to foreign countries located in the south. The Europeans who visited Japan in the 16th century were not *Namban* people in this sense of the term, but were so labeled because they came by way of Malaya or the East Indies and moreover were frequently accompanied by genuine *Namban* men as their servants. As far as Japan is concerned, therefore, *"Namban"* means "foreign countries" or "peoples of or from the south."

The potentate Oda Nobunaga and his successor, Toyotomi Hideyoshi, were both patrons of *Namban* art. Ota Gyuichi (1527-?), a warrior in their service, wrote: "The collections include twill and fancy gauze silks, colorful patterned-weave silks, embroideries, gold brocades and gold-thread gauze silks from Korea, Ryukyu and Nanban, as well as all conceivable kinds of special products of China and India."[20] Here the term *"Namban"* is used in its wider sense to include Europe.

As the geography of the world became better known, the Japanese gradually realized that the Europeans came from the West (Europe), and that their facial types were different from those of the true *Namban* people. Thus they replaced *Namban* by *Komo* (red-haired) in reference to the Dutch people. From this one may deduce that the term *Namban* as used in Japan had only a geographical meaning.

NOTES

1. Archives of the Otomo Family.
2. *Nampo Monju* (Collected writings of the Zen priest, Nampo Monshi).
3. Written by the Spanish Dominican, Cardinal Luis de Granada. First published in Toledo under the title *Libro tercero de la Oracion que se llama Guia de pecadores,* 1556. English translation published in 1598.
4. Pan Ku, *Han-shu* (History of the Han Dynasty); *Hsi-yü-chuan* (Treatise on Central Asia).
5. Fan Yeh, *Hou-han-shu* (History of the Later Han Dynasty); *Hsi-yü-chuan* (Treatise on Central Asia).
6. *Ibid.*
7. *T'u-hui pao-chien* (prefaced dated 1365) was compiled by Hsia Wen-yen. The reference to Wei-ch'ih i'seng is quoted by Chin Wei-no in his article, "Yen Li-pen yü Wei-ch'ih I'seng," *Wen wu,* 1960, no. 4, pp. 61-69.
8. Ishida Mikinosuke, *Choan no Haru* (Spring in Ch'ang-an), Tokyo, 1942.
9. Ch'en Wan-li, *Chung-kuo-ch'ing-tzǔ-shih-lüeh* (An outline of the History of Chinese celadon), Shanghai, 1962.
10. *Wên Wu,* 1958, no. 9, pp. 44-45; 1959, no. 10, pp. 57-60; 1963, no. 1 pp. 20-24.
11. Ho Ch'iao-yüan, *Min Shu* (History of "Min" or the present Fukien Province, Ch'ung-chen period, 1628-1644).
12. Ou-yang Hsiu, *Hsin-t'ang-shu* (New history of the T'ang Dynasty); *Ta-shih-chuan* (Treatise on the Islamic Empire).
13. Ou-yang Hsiu, *Hsin-t'ang-shu* (New history of the T'ang Dynasty); *T'ien-shên-kung-chuan* (Biography of Tien Shên-kung).
14. Hsü Ch'üan, "Ch'üan-chou hai-wai chiao-t'ung po-wu-kuan." Wen wu, 1959, no. 10, pp. 57-60. Ishida Mikinosuke, *Nankai ni Kansuru Shina Shiryo* (Chinese materials concerning the South Seas.), Tokyo, 1945.
15. J. A. Lloyd Hyde and Ricardo R. Espirito Santo Silva, *Chinese Porcelain for the European Market.*
16. *Monumenta Xaveriana ex autographis vel ex antiquioribus exemplis collecta,* Madrid, 1899-1900. Revised by Georg Schurhammer and J. Wicki, in *Epistolae S. Francisci Xaverii,* 2 vols. Rome, 1944-45. A Japanese version of the work by Schurhammer and Wicki appears in *Sei Furanshisuko. de. Sabieru shokan-sho* (Letters of St. Francisco de Xavier) by Fr. Aruppe and Inoue Ikujiro, joint translators, Tokyo, 1949.
17. *Wên Wu,* 1962, no. 10.
18. Jên Hung-chün, essay on "Science" in *Shina Bunka Ronso* (Collected Essays on Chinese Culture), ed. Ishida Mikinosuke.
19. *Shih-chün-t'u-ts'ê-chuan-lüeh* (Epitaph for Lang Shih-ning, i.e. Giuseppe Castiglione and commentary on the "Album of the Ten Steeds").
20. *Ota Gyuichi Zakki* (Miscellaneous essays of Ota Gyuichi, 1527—ca. 1610). Manuscript in the Tokyo University Library.

NAMBAN ART Tadashi Sugase

—1—

The visit of St. Francis Xavier to Japan in 1549 opened the way for other European missionaries, who brought Christianity to the islands. The first to arrive were Portuguese Jesuits, who had been preceded a few years earlier by Portuguese traders. Some local lords or *daimyo* accepted both Jesuits and traders; particularly in the area that was later to become the great port city of Nagasaki, they were permitted to create a center of culture and to build a church, a seminary, port facilities and living quarters for the merchants. The degree of toleration, however, varied with the changing political situation. By 1587, when the number of Christian converts was estimated at over 100,000, Toyotomi Hideyoshi, the military dictator who was engaged in the unification of Japan, issued a decree ordering all missionaries expelled from the country. The ban was imposed for political reasons, and was not actively enforced. Ten years later, however, irritated by open conflicts between the Portuguese Jesuits and the Spanish Dominicans, Hideyoshi ordered the execution of 26 Christians at Nagasaki, of whom nine were Europeans and seventeen native Japanese. This episode cast a dark shadow on the future of Christianity in Japan. Nevertheless, Tokugawa Ieyasu (1542-1616) who succeeded Hideyoshi and became absolute ruler of Japan in 1600, returned to leniency, mainly for economic reasons, as at that time religion and trade were inseparable. It was in the last decade of the 16th century and the first of the 17th that most of what has come to be known as *Namban* art was produced.

As Ieyasu established his military supremacy and consolidated his position, his policy *vis à vis* the Christians rapidly changed. He was well aware that Christians had a higher loyalty to the Pope in Rome than to their Japanese ruler, and since he was primarily interested in trade, he began to encourage the Protestant Dutch and British, who brought with them no religious entanglements. In 1612 Ieyasu imposed his first ban on Christian activities in Japan. As a result of a second ban in 1614, most of the missionaries were rounded up from all over Japan, and together with a goodly number of their Japanese helpers, were expelled to Macao and Manila. Among them was Takayama Ukon, one of the leading Christian *daimyo*, who was also noted for his accomplishments in the art of the tea ceremony. A number of missionaries and their catechists evaded detection and continued to work in disguise among the Christians scattered throughout the country, who in 1600 had numbered around 300,000. This was all part of a new isolationist policy, which aimed to sever all connections with the outside world, and in time even the Dutch and British were affected. Whereas the latter ceased all trading activities, in 1641 the Dutch were allowed to retain one small trading post, on the tiny artificial island of Dejima, just outside Nagasaki harbor, which had been constructed in 1635 to serve as a quay and a residence for the Portuguese. For the next two hundred years, this was the only link with the West, until the arrival in 1853 of Commodore Matthew Perry in charge of a U.S. squadron, whose mission it was to seek trade relations with the Japanese government.

Under the Tokugawa government the persecution of Christians was extremely severe. There were numerous executions of both missionaries and their converts. Finally, in 1637, a peasant rebellion, sparked by economic as well as religious causes, occurred in Shimabara, Nagasaki Prefecture. Some 37,000 rebels, most of them Christians, were killed after three months of fierce resistance to the government forces, who had the support of armed Dutch merchant vessels. With this action, the Christian faith that once had spread so rapidly and had lasted for nearly ninety years was practically extinguished in Japan as an organized religion.

—2—

If the Tokugawa government turned more isolationist after the rebellion, the most visible and force-

ful aspect of this policy was directed towards the suppression of Christianity. The few remaining Christians among the population went underground, and for them it was a period of suffering with no end in sight. The methods employed by the government to flush out Christians were both sinister and effective. One of them was an informer system, which was thoroughly implemented. Notices were posted all over Japan announcing a scale of rewards. A typical one, distributed in 1682, stated that the highest sum, 500 silver pieces, would be paid to anyone informing on a priest, while 300 silver pieces would be paid for an *irmâo* (catechist) or a re-convert. The reward for informing on a native Christian, or anyone who lived in a priest's household, was 100 silver pieces. However, this latter sum could also be increased to 500, according to the character of the suspect. Moreover, failure to reveal the hiding place of suspected Christians would make the chief and certain representatives of a town or village liable to severe punishment. An earlier anti-Christian measure, which was introduced in the 1620's, was the law obliging the entire population of an area to trample upon a picture of Christ or of the Virgin Mary, a form of spiritual torture for devout Christians. Each Japanese was also required by law to register once a year at a temple in his area. In these and other ways the government sought to eradicate Christianity in Japan.

The ban on Christianity, coupled with the strictly isolationist policies pursued by the Tokugawa government for two hundred and fifty years, distorted Japanese attitudes towards the Christian faith, as well as towards foreign affairs. These policies also effectively helped to destroy much of the cultural heritage that had been created during the period that Japan had had contact with European countries.

Namban art—the European art introduced into Japan by Catholic missionaries around the middle of the 16th century, and subsequently copied by the Japanese—also suffered an eclipse. Most it was systematically destroyed, and it is only by chance that some pieces have survived. Not until this century have we become aware of what does exist. One good example is the *Portrait of St. Francis Xavier* (Cat. No. 9) which was discovered in 1920, concealed in the space above the ceiling of a farmhouse in a mountainous area of Takatsuki, Osaka. The box that held it had remained tied to a beam in the ceiling, unknown to anyone, for over three centuries.

Another remarkable case of survival is the *St. Peter* (Cat. No. 8). Throughout the Edo period, when it remained at Kakuo Temple in Chiba, the painting bore the title given it by the temple, *The Lord Buddha Coming Down the Mountain*. This false description helped it evade official detection. The same is true of other pieces that escaped destruction simply because they were designated temple property. In these circumstances, it is miraculous that we have been left with any *Namban* art at all.

For these reasons, today's student of *Namban* art faces formidable difficulties. First, the surviving pieces are too few to permit us to establish a clear over-all perspective of the art as it existed from the late 16th to the early 17th century. Secondly, in Japan there is scant literature to substantiate any findings; the reports dispatched by Jesuit missionaries throw a little light on various aspects, but they are virtually no help when it comes to establishing dates and the names of individual artists.

—3—

As we have mentioned earlier, the first European art introduced into Japan was religious in character. It is known that St. Frances Xavier had with him an oil painting of Christ and the Virgin Mary when he reached Kagoshima in 1549. According to Xavier's letter, he showed the painting to Shimazu Takahisa, the local *daimyo*. On beholding the picture, Takahisa fell

on his knees, bowed reverentially to it, and straightway ordered his subjects to do likewise. Takahisa's mother was especially moved, and later sent word to Yajiro, the Japanese Christian convert who had guided Xavier from Goa, that an exact copy should be made, regardless of cost. Unfortunately, however, there was at that time no painter skilled in copying in Kagoshima, so her wish went unfulfilled.

How much understanding a mid-16th century *daimyo* and his mother had of Christianity is a matter of speculation (most likely, they took Xavier to be a representative of a new sect of Buddhism direct from India), but Xavier's letter describes vividly how a religious picture, painted in colors that were both dignified and attractive, could captivate the Japanese imagination. Art has always played an important part in the interpretation of religion in the Catholic Church, and here, where verbal communication was extremely difficult because of language barriers, such pictures were all the more desirable. Xavier seems to have had other pictures with him for missionary purposes. When he left Kagoshima, he gave a painting of the Annunciation to Miguel, or Nino, lord of Ise, the chief steward of Ichiki Castle. Also, according to the memoirs of Fernando Mendes Pinto, when Xavier was granted an audience with Otomo Yoshitane before leaving Japan in 1551, Pinto saw in the missionary's procession heading towards the castle "a painting of the Virgin Mary wrapped in a purple silk cloth."

In the years that followed, the number of religious pictures shipped to Japan evidently increased. To cite a few other instances: in a letter dated November 17, 1563, Luis de Almeida, S.J., says that he baptized the converts in the Shimabara area under a beautiful altar painting of the Virgin Mary, and Juan Fernandez, S.J., reports in his letter dated April 17, 1563, that he saw a picture of the Virgin Mary in the Ikkaido Chapel on Ikutsuki Island.

—4—

As the number of Christian converts grew, it became more and more difficult to satisfy the need for religious art solely with that brought to Japan on foreign ships. It is estimated that there were between twenty and thirty thousand Japanese Christians in 1570, but the number increased to 200,000 by 1590, and as we have already noted, rose to about 300,000 by 1600. Quite naturally, then, Japanese artists turned to making their own sacred pictures. Luis Frois, S.J., reported that when he built a chapel in Sakai in 1565, one of his proselytes, a gold- and silversmith, contributed two pictures for its decoration, one showing the Nativity and the other the Resurrection. In that same year Luis de Almeida, S.J., wrote that when he visited Sawa Castle in Yamato, the residence of the aforementioned Christian *daimyo*, Takayama Ukon, he saw a small but well-built chapel in the castle compound in which there was a picture of the Resurrection, the work of a celebrated native painter, executed as skillfully as any found in Europe.

From these reports we know that already in the 1560's Japanese artists — some well-established ones among them — were painting Christian subjects. Unfortunately, however, because no works from that period survive, it is not clear what techniques were used and in what style they were painted. The obvious assumption is that they were copied from paintings or engravings imported from Europe and that the artists used traditional Japanese techniques and pigments. From reliable documents we know that it was only after the establishment of seminaries in various parts of Japan, and especially after the arrival of Giovanni Niccolo in 1590, that the Japanese had a real opportunity to master European painting techniques. This will be discussed further in the following section.

—5—

In 1579, Alessandro Valignano, a Visitor of the Society

21

of Jesus, came to Japan, and his presence gave a strong impetus to the spread of Christianity among the Japanese. Among his major contributions was the establishment of educational institutions primarily intended to train Japanese missionaries. These included seminaries in Arima and Azuchi, a college of higher education in Funai and a novitiate in Usuki, both in Bungo Prefecture.

The seminaries in Arima and Azuchi, established in 1580 and 1581 respectively, soon began to offer instruction in European painting techniques. Later, when repressive measures became harsher, these seminaries had to change their location. In his annual report covering the 1591-2 period, Luis Frois said that his students learned Latin well and were free to engage in a variety of undertakings of their own choice—painting, casting printing types and engraving—and that the skills thus acquired were proving useful. The students' ability to learn a handicraft was astonishing, according to Frois, and they mastered a variety of techniques with apparent ease. Valignano, coming to Japan for a second time in 1590 with the four young Japanese noblemen who were returning from a mission to Europe, had brought with him a Portuguese typecaster and a printing machine.

From the annual report of Pedro Gomez, S.J., for the year 1593-4 we learn that at the seminary in Hachirao on the Shimabara peninsula, among the art students eight were working in tempera, eight in oils, and five were practicing engraving. Several of them, Gomez went on to say, produced paintings that were much superior to those brought back by the Japanese mission, and it was even claimed that they could be mistaken for work done in Rome. Gomez optimistically foresaw the day when each Jesuit church would be able to own good paintings and it would be possible to supply the needs of numerous Christian *daimyo*. Furthermore, he reported that the students learning engraving techniques were also working hard, skill-fully copying the examples brought back from Rome and printing a great number of them, and that soon religious pictures would be provided for the homes of individual believers, many of which had none.

Other missionary reports include a reference to a school of arts in Shiki, Amakusa, where in 1592 more than twenty individuals were studying painting and engraving, and to the establishment of a printing shop and school of painting in Nagasaki in 1602. As concerns the latter, Fernaõ Guerreiro, S.J., reported that one of the two missionaries teaching painting there had recently arrived from Rome, and was so effective as a teacher that many churches in Japan now had painted altarpieces. This was the aforementioned Father Giovanni Niccolo. Born in Nora, near Naples, in 1560, Niccolo entered the monastery of the Society of Jesus in Nora in 1577. Later he learned engraving in Rome, and in 1583 he came to Japan. By 1586 he had produced several religious paintings in Nagasaki and Arima. In 1592 he joined the staff of the school of arts in Shiki, Amakusa, and in 1601 he taught at the painting school, finally coming to Nagasaki in 1602. Thus it is clear that it was in the last decade of the 16th century that the Japanese were really able to study European types of painting, at which time a large body of work in this genre began to be produced.

—6—

As has already been noted, however, all too few of the religious paintings, which must have constituted the most important segment of Namban art, have survived. Consequently, we are forced to rely on the decorative painting done on large screens, illustrating foreign topics and mostly of a secular nature, to help us form an idea of the genre. These, too, are derived from Europe, but are copied from engravings rather than from paintings.

Let us consider, for example, two sets of

screens depicting a similar subject, the so-called "*Western Kings on Horseback*" (Cat. Nos. 1 and 2). The first set, believed to have formed part of the mural in Aizu-Wakamatsu Castle, once the residence of a prominent Christian *daimyo*, Gamo Ujisato (1556-96), show magnificent figures of kings, most likely copied from some engravings imported from Europe. The second set, now in the collection of the Kobe City Museum of Namban Art, which depicts a duel between Catholic and Islamic monarchs, seems to have been painted with the idea of stressing the aggressive missionary spirit of the Society of Jesus. Although the paper and pigments appear to have been Japanese, glue and the white-of-egg were used as a binding agent, a technique we associate with tempera. The shading is also Western. We must realize that the subject matter here would have appealed strongly to the people of the Momoyama period (1568 to 1615). An age of destruction and construction, a time of imminent death and joy of living, Momoyama typified heroism and glory for the *daimyo* who dominated the scene. It is easy to imagine that, with or without religious implications, any *daimyo* would consider such paintings appropriate for the decoration of his castle interior. Furthermore, the use of vivid coloring against a gold background was also characteristic of the spectacular mural painting of that period. The Momoyama period was, above all, a time of great cultural receptivity and one can safely assume that people were delighted with such foreign scenes as appeared on the screens *Western Customs and Manners* (Cat. Nos. 3 and 4).

The "Christian art" thus appealed to an unexpectedly wide range of people. "Things Namban" became particularly fashionable in the 1590's. In 1590 the previously mentioned Alessandro Valignano, S.J., came to Japan for a second time, as ambassador from the Viceroy of India. In March of the following year he went to Kyoto, accompanied by the members of the Japanese mission sent to Europe by three Kyushu *daimyo*, who had returned with him to Japan, and he was received by Hideyoshi at Jurakudai. Their procession—with two Arabian horses, numerous gifts of objects hitherto unknown, the foreigners in their colorful, unfamiliar attire—captivated the Japanese spectators and instantly generated a longing for foreign things. All Japanese, of whatever station in life, were affected by *Namban* culture. During the Korean campaign (1592-3) when Hideyoshi set up his headquarters at Nagoya, Hizen (now partly in Saga and partly in Nagasaki Prefecture), its proximity to the international port created a "*Namban* boom" among the soldiers gathered there from all over the country. Both high-ranking officers and ordinary soldiers were delighted to wear clothes in the *Namban* style, and all the tailors in Nagasaki were kept busy with mountains of work. It was also fashionable to wear amber balls, gold chains and buttons, and it is said that some went so far as to find pleasure in eating eggs and beef. At no time in their history were the Japanese reluctant to assimilate foreign cultures, but during this particular period of the 16th century, it looked as though the *Namban* craze was about to sweep through the country.

—7—

This extraordinary enthusiasm for all things foreign served to provide a greater variety of subject matter for paintings in the Western style. The traditional Japanese artists also made use of Western objects and motifs in their painting and in their handicrafts.

The best examples of this are the *Namban* screens, some of which have been mentioned earlier. Such screens usually depict such conspicuously exotic subjects as ships (mostly Portuguese), Westerners (also mostly Portuguese) and Christian churches. The approximately sixty sets that still survive may be divided into three categories in terms of their pictorial composition. In the first category we most commonly find screens which show on the left a foreign ship entering

a Japanese port, and on the right, a newly-landed group of foreigners, a church, and an occasional cluster of missionaries. The second category comprises screens with a foreign port on the left half and a Japanese port on the right (Cat. No. 11). In the third category we may include screens with the figures of foreigners on the left half and a Japanese port on the right. Stylistically, the screens are close to the mural paintings of the Momoyama period, done primarily for decorative purposes and carried out in strong colors against a gold background. Although the presentation is generally stylized, it is curious to note that some subject matter is treated quite accurately. The ships entering the ports give a fairly good picture of the large trading vessels sent to Japan by the Portuguese government in the 16th and 17th centuries. Similarly, the missionaries of the Society of Jesus and those of the Franciscan and Dominican Orders are clearly differentiated by their habits.

A great number of these *Namban* screens were probably made in the 1590's, reflecting the bustling trade in Nagasaki during that period. While the screens seem to have been executed by painters of the Kano school, who worked mainly for *daimyo*, the nobles at court and for Buddhists, they were most probably commissioned and bought by the Japanese merchants who were engaged in foreign trade. These paintings show their dreams and aspirations, as well as their pride and interest in their ventures.

Finally, in the decorative arts a wide range of *Namban* subject matter was freely used. This could be secular, such as foreign ships, foreigners, *Namban karakusa* (China grass) designs, playing cards known as *un sun carta*, pipes of various descriptions and *sarasa* designs, or religious, such as the Cross. The unprecedented vitality of Momoyama art was in large measure due to the incorporation of such foreign elements.

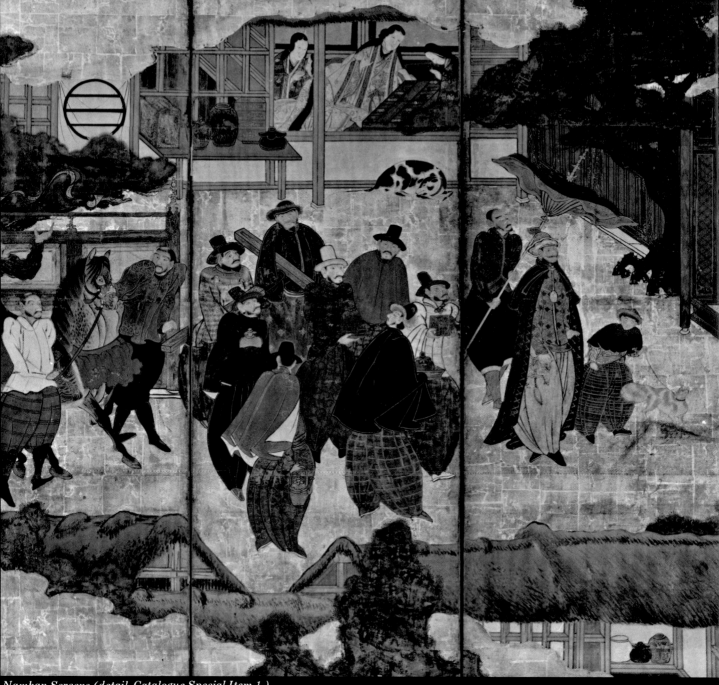

Namban Screens (detail, Catalogue Special Item 1.)

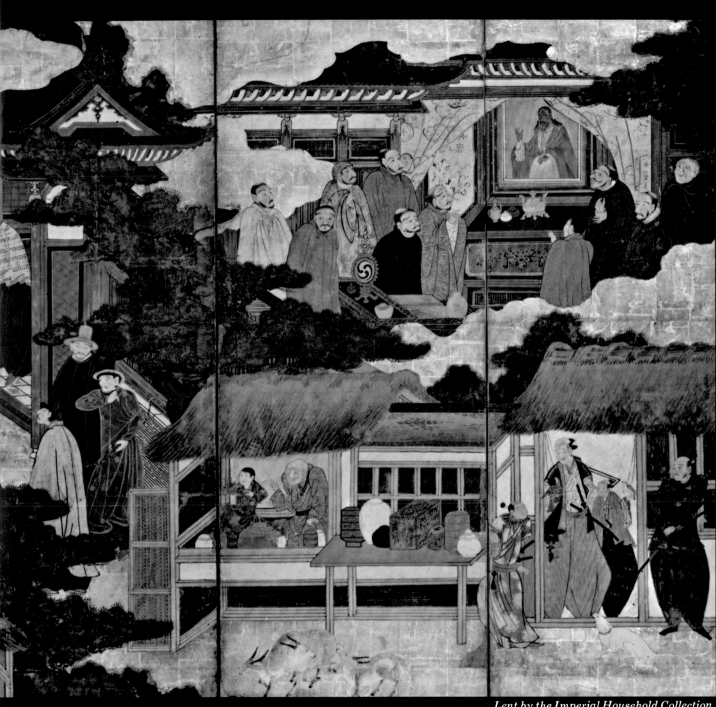

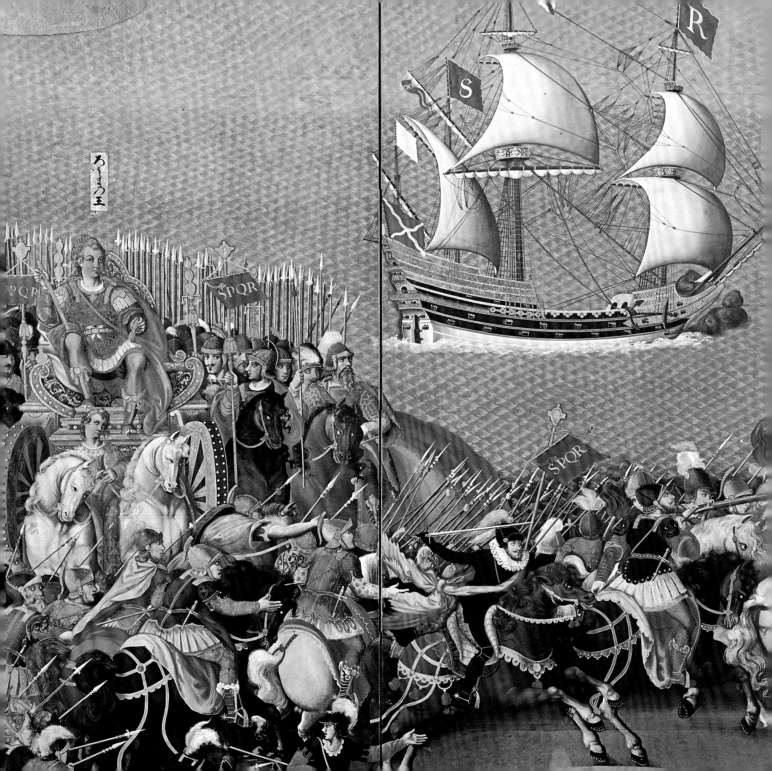

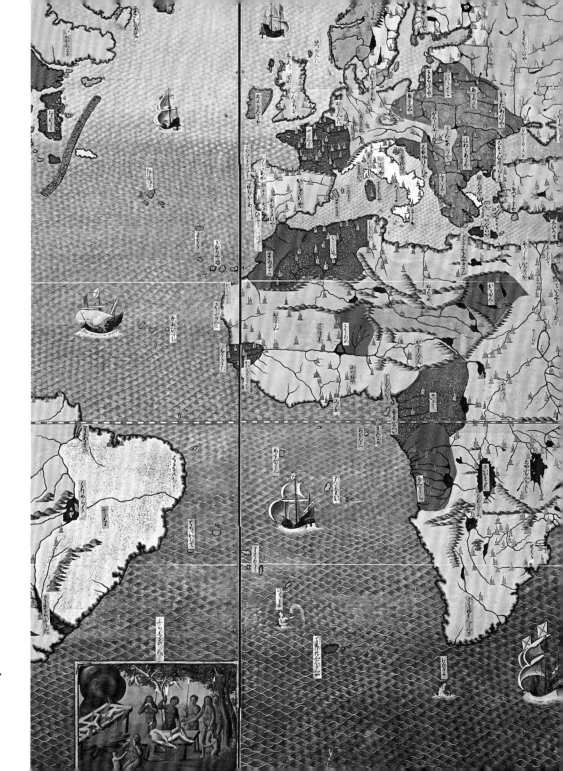

Map of The World and
The Battle of Lepanto (detail,
Catalogue Special Item 2.)
Lent by Mr. Nagataka Murayama,
Kobe, Hyogo Prefecture

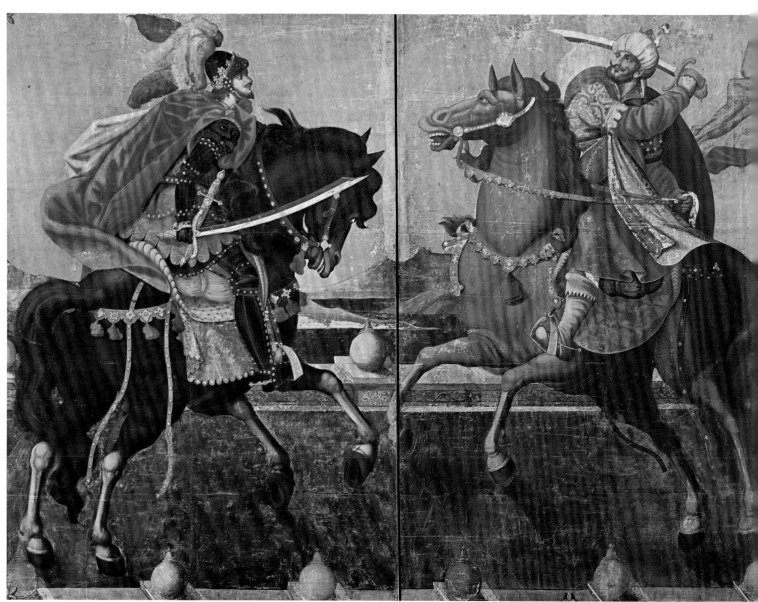

Western Princes on Horseback (Catalogue 1.)

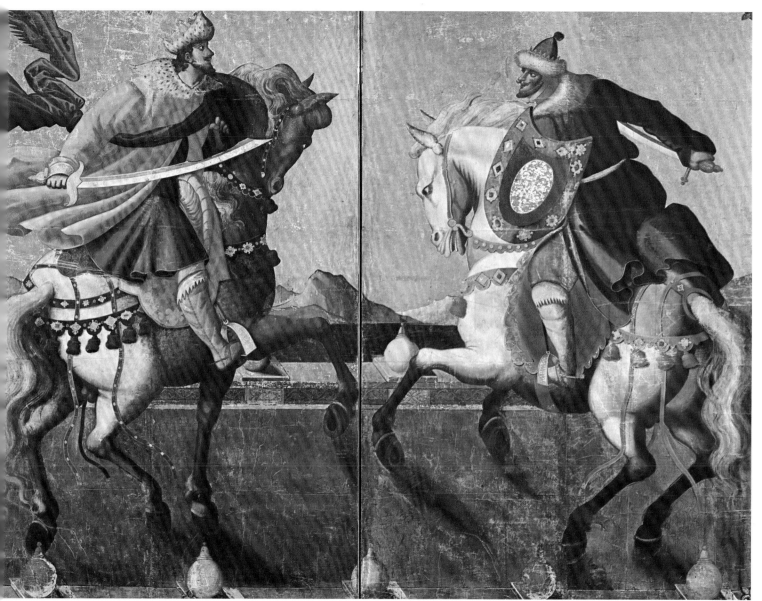

Lent by Kobe City Museum of Namban Art

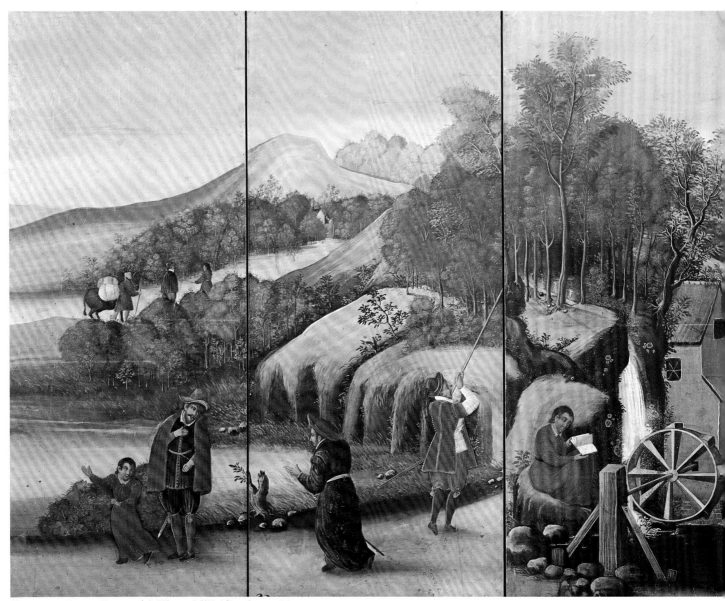

European Genre Scene with Water Mill (Catalogue 3.)

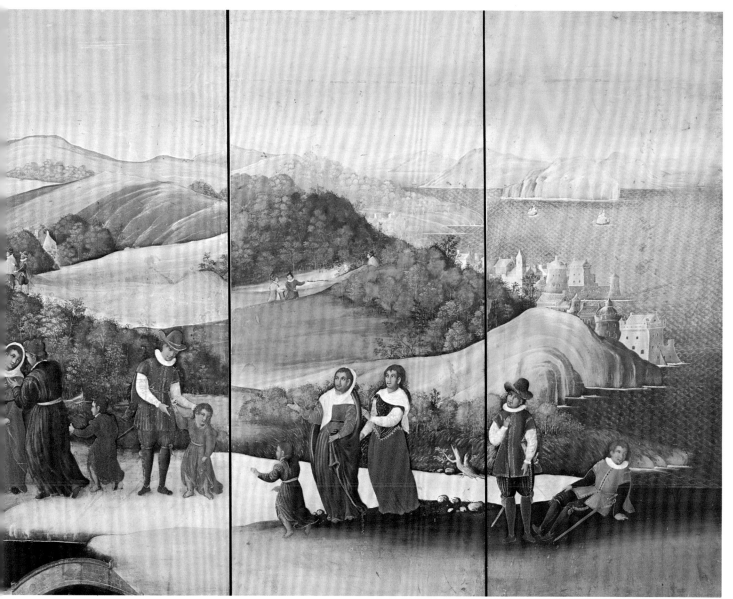

Lent by Mr. Ichio Kuga, Osaka

33

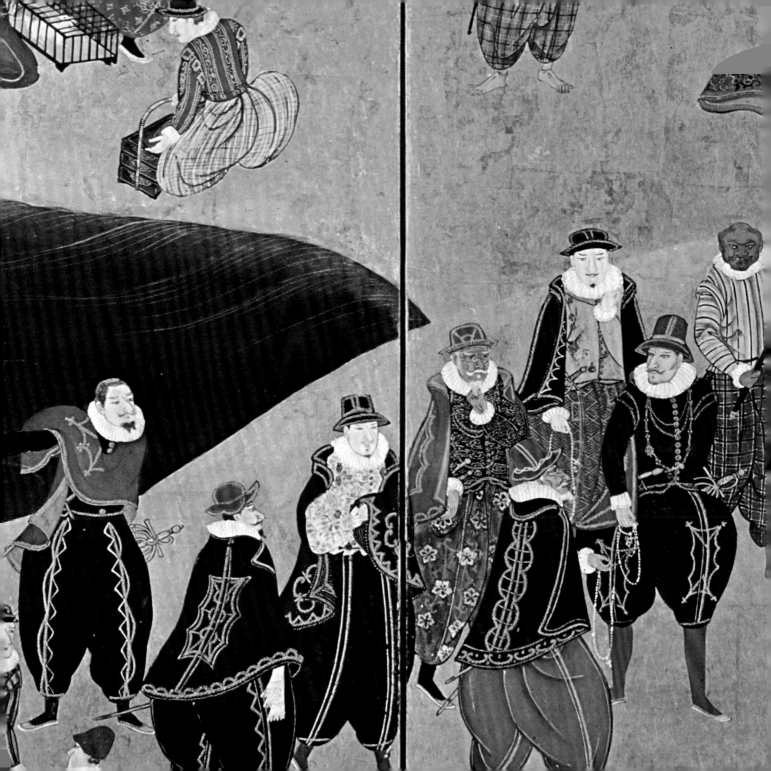

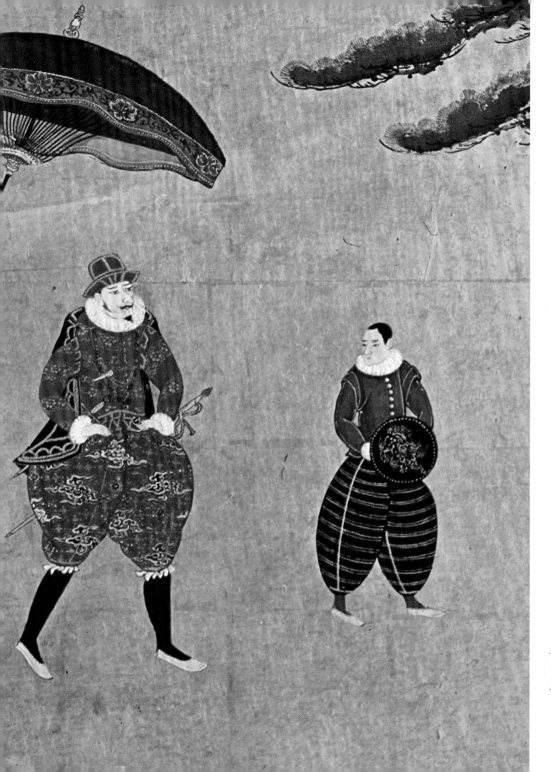

*Namban Screens by Kano Naizen
(detail, Catalogue 11.)
Lent by Kobe City Museum of
Namban Art*

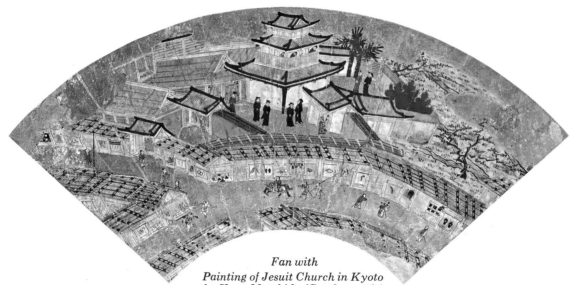

Fan with
Painting of Jesuit Church in Kyoto
by Kano Motohide (Catalogue 13.)
Lent by Kobe City Museum of Namban Art

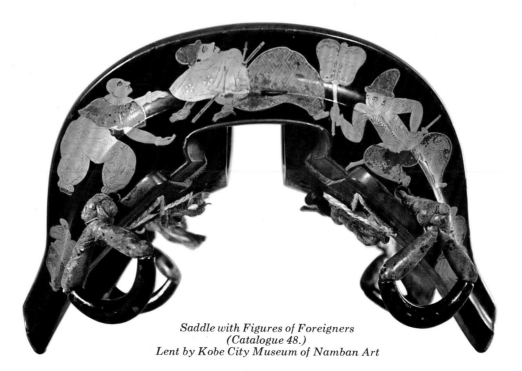

Saddle with Figures of Foreigners
(Catalogue 48.)
Lent by Kobe City Museum of Namban Art

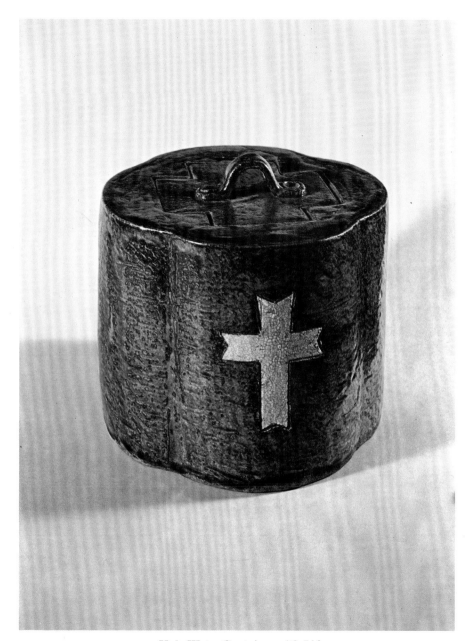

Holy Water Container with Lid
in the Form of a Mokko Cross,
Decorated with a Cross (Catalogue 28.)
Lent by Mr. Ichio Kuga, Osaka

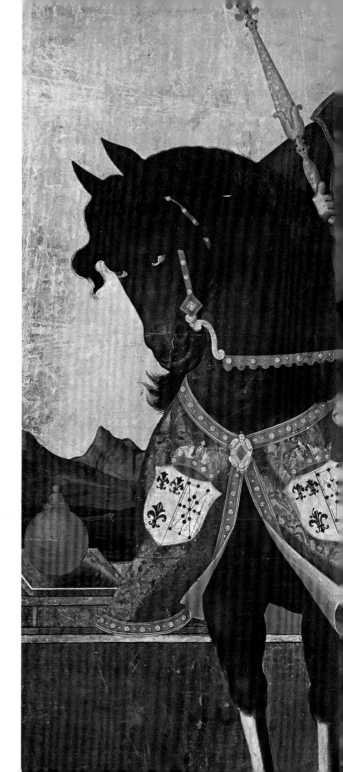

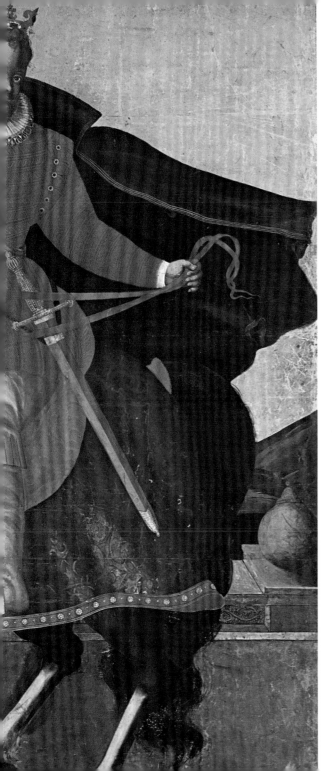

Western Princes on Horseback
(detail, Catalogue 2.)
Lent by Mr. Akira Fujii,
Nishinomiya, Hyogo Prefecture

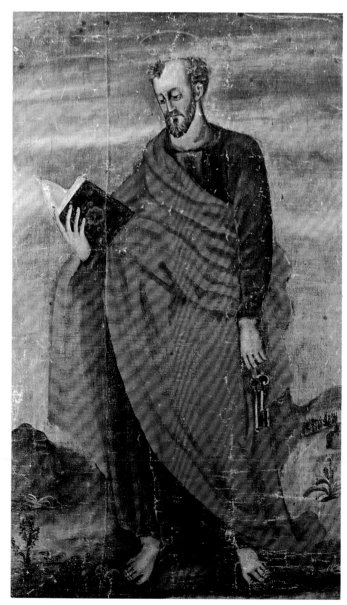

St. Peter (Catalogue 8.)
Lent by Namban Bunkakan, Osaka

Catalogue and Plates

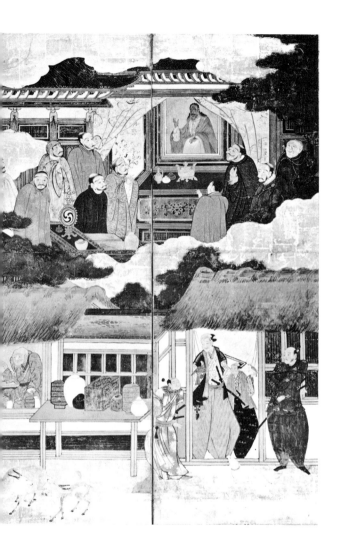

Special Item 1.
Namban Screens

Late 16th Century
Pair of six-fold screens, painted in color on gold-leafed paper
61¼″ x 131⅝″ each (155.8 cm x 334.5 cm each)
Lent by the Imperial Household Collection

"Namban Screens," which, strictly speaking, should be referred to as "the Screens of the Namban Boat's Arrival" or "the Screens of Namban People's Arrival," depict scenes at the time when Namban-jin came to Japan in the 16th-17th centuries. The name, *Namban-jin,* was borrowed from the Chinese who referred to foreigners in the Southern countries by this term; among Japanese of the period, the name was applied to Portuguese and Spaniards who arrived in Japan.

On the right wing of this screen, the procession of Namban people arriving in Japan is painted as a central design. The procession with a captain in the lead proceeds towards the gate of a Namban temple (or Christian church); inside the church, on an altar, a depiction of the "Savior Christ" is hung, and in front of this a few missionaries are seen.

On the left wing is a Namban boat arriving in a Japanese port and unloading goods. This is painted in large scale.

It is believed that Tokugawa Ieyasu, one of the great military dictators and unifiers of Japan in the early 17th century, gave these screens to the Raigoin temple in Shizuoka. More recent and evidently reliable documents indicate that the governor of Shizuoka presented the screens to the Tokugawa family in 1889, and they in turn gave them to the Imperial family.

A temple document at Raigoin says that an artist of the Tosa school painted the screens. However, the brushwork is most characteristic of the Kano school, specifically of its "early style" developed by Kano Eitoku (1543-90) and his disciples.

Such Namban Screens as these are respectively different from one another in design. At present, there remain about sixty screens. These screens are not only in Japan but also in Europe and in the United States. In the United States, those held by the Freer Gallery, the Cleveland Museum of Art and the M.H. de Young Memorial Museum are well known.

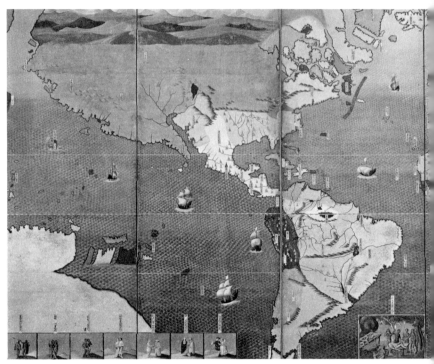

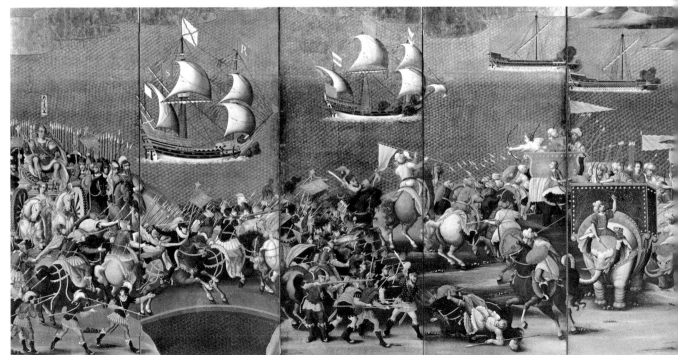

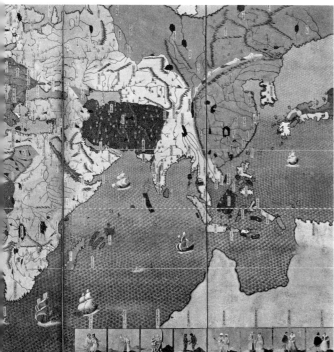

Special Item 2.
Map of the World and The Battle of Lepanto

First half of 17th Century
Pair of six-fold screens, painted in color on paper
60½″ x 145⅞″ (153.8 cm x 370.6 cm each)
Lent by Mr. Nagataka Murayama, Kobe, Hyogo Prefecture

On October 7, 1571, the joint naval forces of Spain, Rome, Venice and Genoa met and destroyed the Ottoman fleet in the straits between the Gulf of Corinth and the Ionian Sea. This naval battle was an outstanding event in the history of Christianity's struggle with Islam. Since no representation of this battle was available to the Jesuit missionaries in Japan, they made use of an engraving by Cornelis Cort, which was copied from a painting by Giulio Romano, titled *The Battle of Scipio against Hannibal at Zama.* These facts were recently established by Sakamoto Mitsuru. In Japan, these screens are traditionally identified with the Battle of Lepanto.

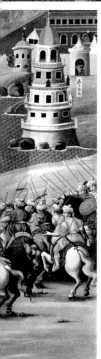

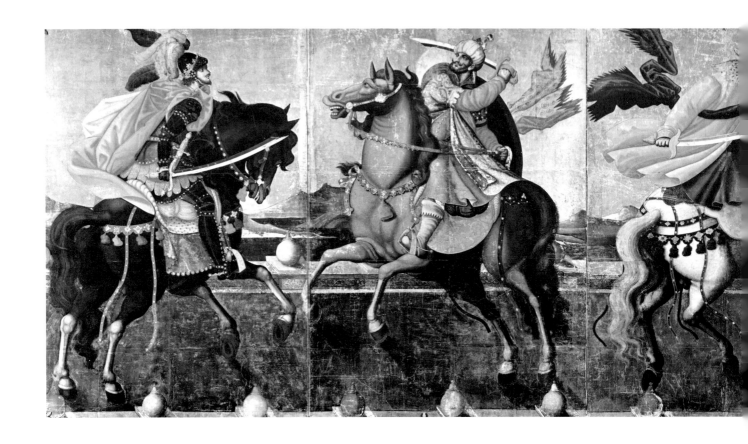

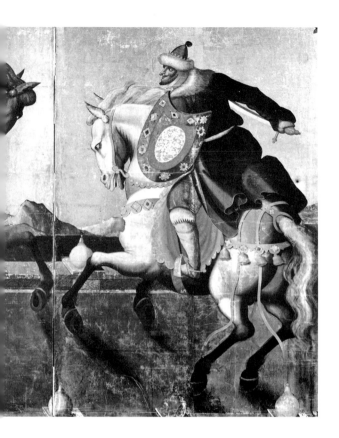

1. **Western Princes on Horseback**

 Late 16th-early 17th Century

 Four-fold screen, painted in color on gold-leafed paper

 65½″ x 181¼″ (166.2 cm x 460.4 cm)

 Registered as Important Cultural Property

 Lent by Kobe City Museum of Namban Art

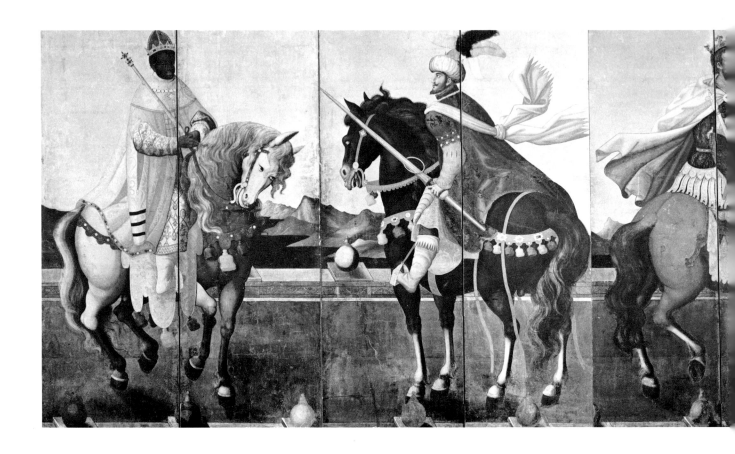

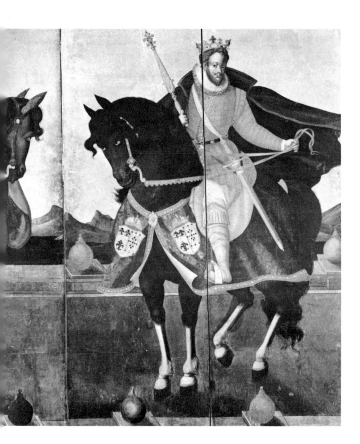

2. Western Princes on Horseback

Late 16th-early 17th Century

Pair of four-fold screens, painted in color on gold-leafed paper

60″ x 91¾″ (167.8 cm x 233.2 cm)

Registered as Important Cultural Property

Lent by Mr. Akira Fujii, Nishinomiya, Hyogo Perfecture

These two paintings (nos. 1 and 2), now owned separately, are believed originally to have formed a pair owned by the lord of Aizu-Wakamatsu Castle in Fukushima. During a battle in 1868, Maehara Issei, chief of staff of the Imperial forces, removed one of them from the castle. It now belongs to the Kobe City Museum of Namban Art. It is the more powerful of the two paintings, and shows two Christian and two Islamic monarchs engaged in a duel. The title given them is a traditional Japanese one; the protagonists in these scenes are not all always from Western Europe, and in No. 2, while two of the monarchs represented are European, one is African and the other Moslem.

The artist used Japanese pigments on especially prepared paper. Glue and the white-of-eggs where used as binding agents, as in tempera.

It is generally considered that the paintings are based on *Engravings of Roman Emperors* by an Antwerp print-maker, Adriaen Collaert, after the paintings by a Flemish artist, Stradanus (Jan van der Straet) or as he is known in Italy, Giovanni Stradane.

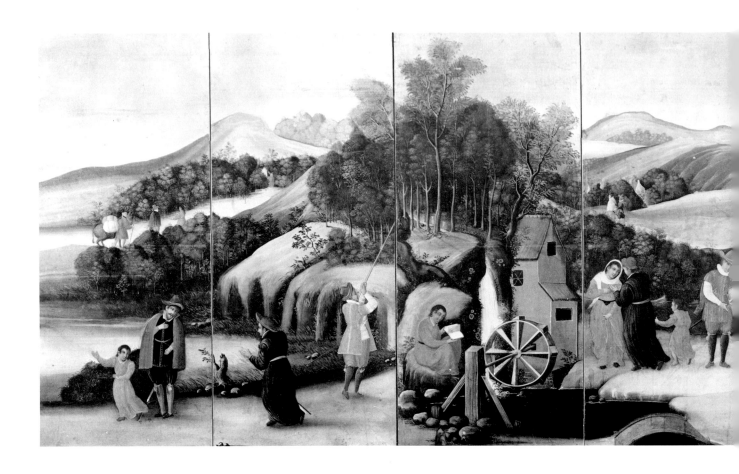

3. European Genre Scene with Water Mill
First half of 17th Century
Six-fold screen, painted in color on paper
40″ x 103⅜″ (101.7 cm x 262.6 cm)
Lent by Mr. Ichio Kuga, Osaka

Screens depicting Europeans against beautiful landscapes
were evidently in popular demand. Other examples
are owned by the Atami Museum, the Hosokawa family
and the Kobe City Museum of Namban Art. Since they are
all similar in style and technique, we can safely assume
that they were enlarged copies of engravings imported from
Europe. This particular one strikingly resembles the
paintings nos. 5, 6 and 7.

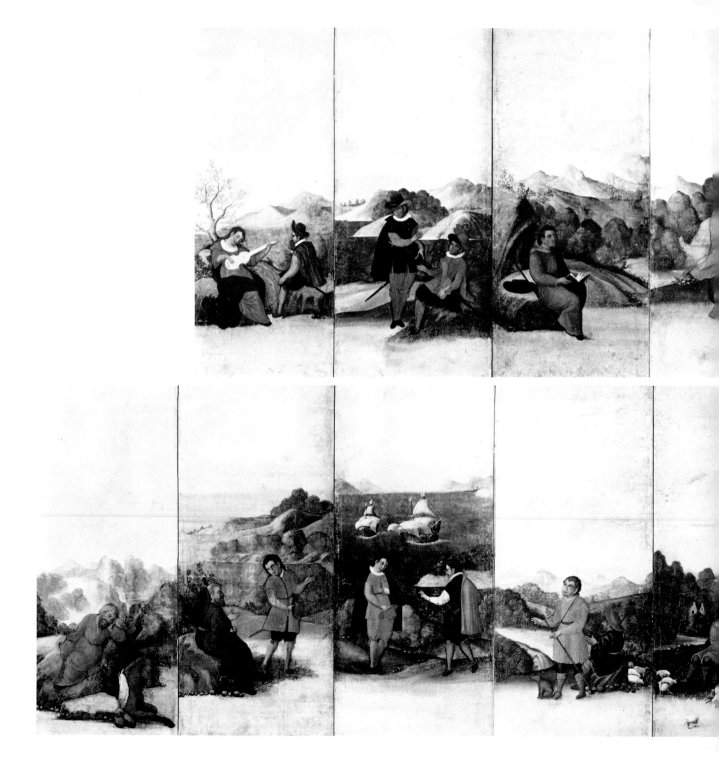

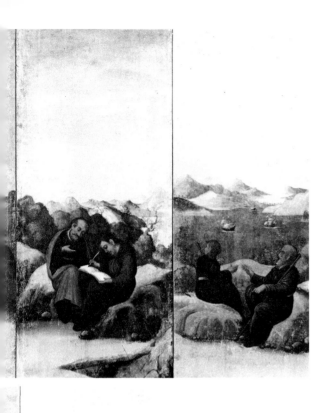

4. European Genre Scenes
First half of 17th Century
Pair of six-fold screens, painted in color on paper
46″ x 121½″ each (116.7 cm x 308.6 cm each)
Lent by Kobe City Museum of Namban Art

Originally owned by the Nambu family, feudal lords in the Tohoku district, the screen was found in 1882 in the Shoju temple in Morioka, their traditional burial place.

This picture, too, has the characteristics of the paintings which carry the seal of Nobukata, who is thought to have been a seminarian of a Jesuit school who mastered the techniques of Western painting. Most probably, Nobukata converted to Buddhism later in life. Shoren Temple in Hyogo owns a portrait of Nikkyo, a priest of the Nichiren sect, which also bears this artist's seal. It was most likely done after his conversion.

Three paintings bearings the seal of Nobukata

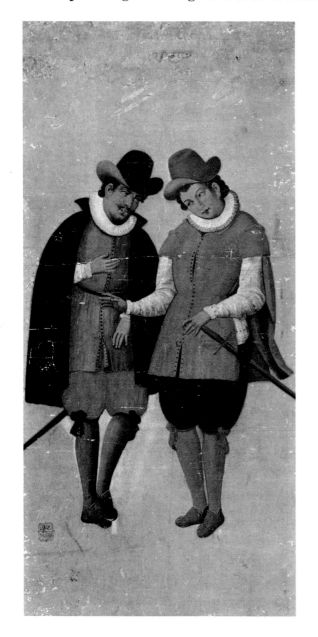 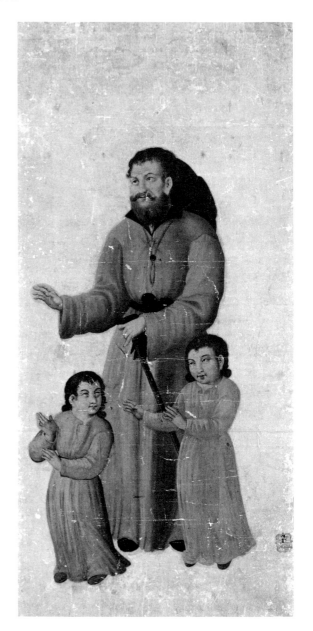

5. Two Western Warriors
 First half of 17th Century
 Framed panel, painted in color on paper
 45″ x 21⅛″ (114.4 cm x 53.6 cm)
 Registered as Important Art Object
 Lent by Kobe City Museum of Namban Art

6. Christian Father and Two Children
 First half of 17th Century
 Framed panel, painted in color on paper
 45⅛″ x 21″ (114.6 cm x 53.4 cm)
 Registered as Important Art Object
 Lent by Kobe City Museum of Namban Art

7. Old Man Reading a Book
 First half of 17th Century
 Framed panel painted in color on paper
 13¾″ x 22″ (35.0 cm x 55.8 cm)
 Lent by Mr. Ichio Kuga, Osaka

Each of the three paintings bears a European seal showing a stylized lion and eagle, and two of them, nos. 5 and 6, have Nobukata's signature superimposed on the seals.

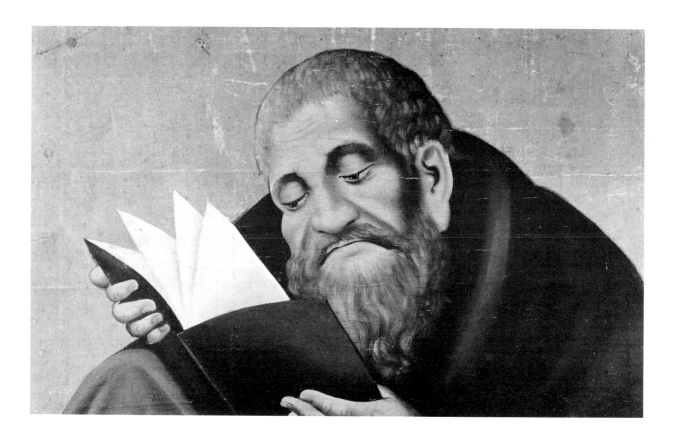

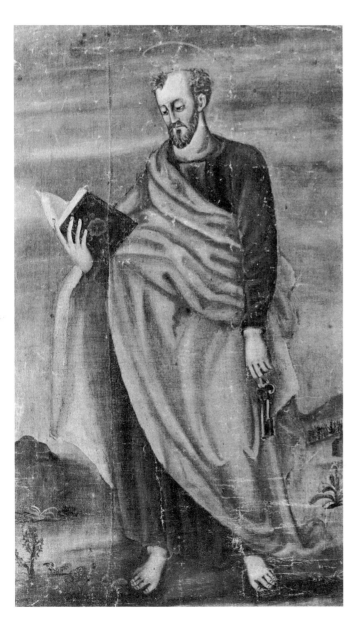

8. St. Peter

First half of 17th Century
Framed panel, oil on canvas
47½″ x 27⅜″ (120.9 cm x 69.6 cm)
Lent by Namban Bunkakan, Osaka

Although the painting clearly depicts St. Peter, while in the collection of the Kakuo Temple in Funabashi, it was known as a *Portrait of the Lord Buddha Coming Down the Mountain.*

There are other representations of St. Peter in existence that were produced at the seminaries of the Jesuit Society, but most of these are engravings, whereas this one is done in oils. It was painted by a minor Spanish artist in the 16th century and brought to Japan. The painting is of interest inasmuch as it shows the type of models which were at the disposal of Japanese artists.

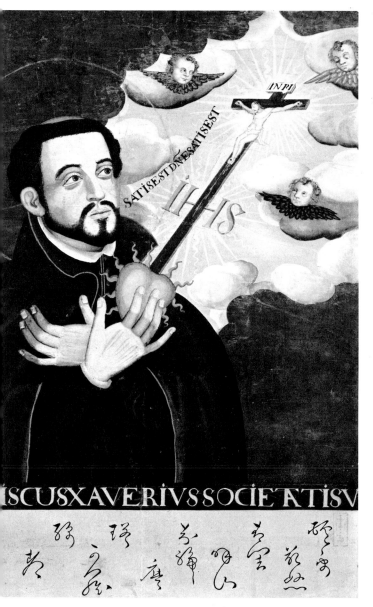

9. Portrait of St. Francis Xavier

First half of 17th Century
Framed panel, painted in color on paper
24″ x 19⅛″ (61.0 cm x 48.7 cm)
Registered as Important Art Object
Lent by Kobe City Museum of Namban Art

The painting was discovered in 1920 in the household of the Higashi family in the mountainous area of Takatsuki, Osaka. Takatsuki was once the fief of Takayama Ukon, a Christian *daimyo*. It is believed that the painting was copied from an engraved frontispiece in the *Biography of Xavier* by Orazio Torsellini (1544-99).

The inscription at the bottom, written in what is known as Manyo *kana*, says: *"san furanshisuko saberyusu sakaramento,"* and is followed by a signature, Gyofu Kanjin, and a seal.

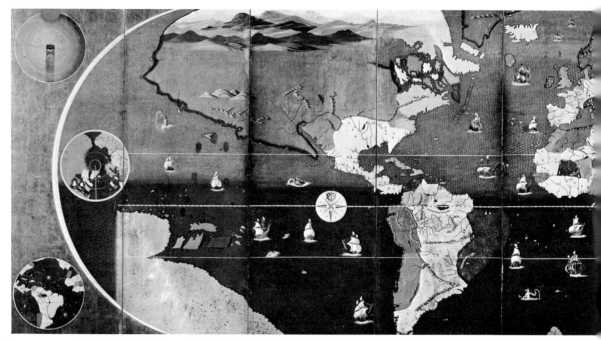

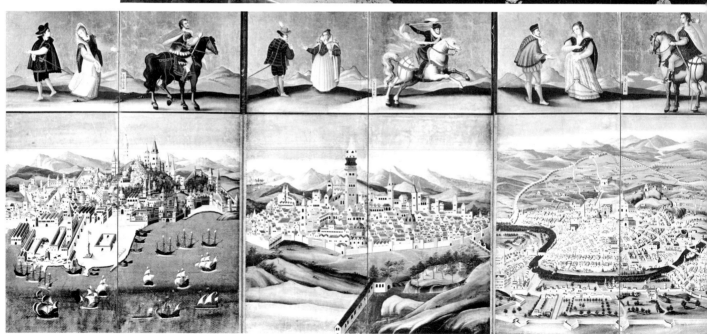

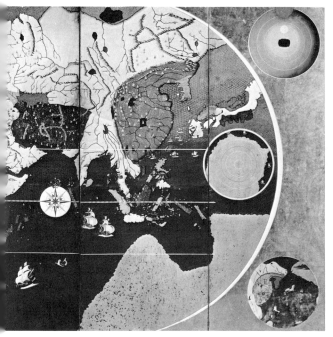

10. World Map and Four Major Cities of the World

First half of 17th Century

Pair of eight-fold screens, painted in color on paper

62½" x 188" each (158.7 cm x 477.7 cm each)

Registered as Important Cultural Property

Lent by Kobe City Museum of Namban Art

The right half of the screen shows a map of the world, and the left half, bird's-eye views of four cities, which are, from right to left: Constantinople, Rome, Seville and Lisbon. In the upper portion of the screen are pictures of men and women in various types of Western dress.

The city views are believed to have been copied from Georg Braun and Franz Hogenberg's *Civitates Orbis Terrarum,* Cologne, 1572, while the map was presumably copied from Abraham Ortelius' *Theatrum Orbis Terrarum,* Antwerp, 1570. These books were probably among the volumes brought back to Japan by the mission sent to Europe by three Kyushu *daimyo,* Otomo, Omura and Arima.

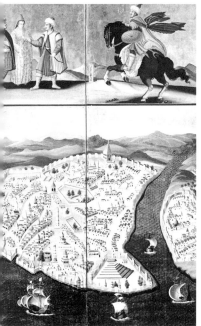

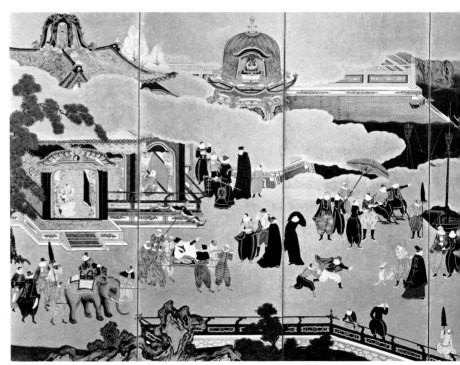

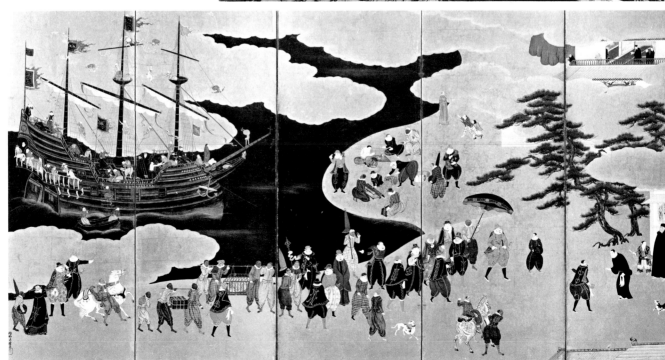

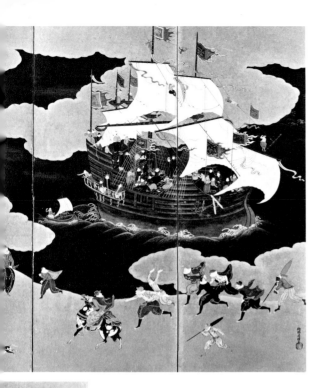

11. Namban Screens by Kano Naizen

Early 17th Century

Pair of six-fold screens, painted in color on gold-leafed paper 60⅞″ x 143″ each (154.5 cm x 363.2 cm each)

Lent by Kobe City Museum of Namban Art

In addition to the screens owned by the Kobe City Museum of Namban Art, there are three others in existence bearing the signature and seal of Kano Naizen. These are owned by Mr. Kawanishi Seibe of Kobe, the Museu Nacional de Arte Antiga in Lisbon, and a private collector in Munich.

Naizen became a pupil of Kano Shoei in 1589 and assisted Kano Mitsunobu in painting the murals of Nagoya Castle in Kyushu. He is also believed to have visited Nagasaki in 1593, the port established by the Portuguese.

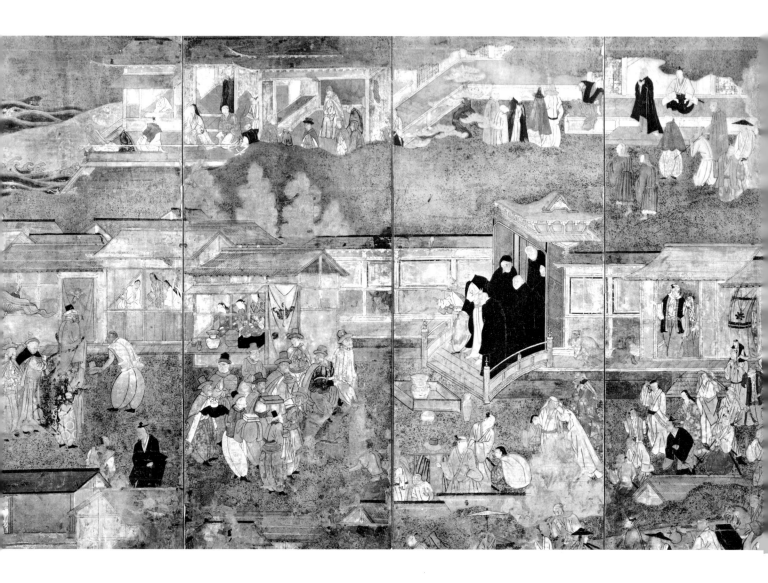

2. Namban Screen

Late 16th-early 17th Century
Four-fold screen, painted in color on paper
54⅜″ x 86½″ (138.2 cm x 219.7 cm)
Lent by Kobe City Museum of Namban Art

This screen is considered to have originally consisted of a pair of six panel-screens. The remaining portion is probably the four panels on the right screen, the top cut off. Most likely, the design of the original was similar to that of the Namban Screens at the Cleveland Museum of Art. If that is the case, the left half must have depicted a Namban ship entering a Japanese port.

Regrettably, this screen has been imperfectly preserved. Further, the use of silver on the ground, instead of gold as is normally the case, has helped to darken the picture.

13. Fan with Painting of Jesuit Church in Kyoto by Kano Motohide

Late 16th-early 17th Century
Painted in color on gold-leafed fan paper
7¾″ x 19½″ (19.7 cm x 50.6 cm)
Lent by Kobe City Museum of Namban Art

This is one of the sixty-one paintings done on fans by Kano Motohide showing the famous sights of Kyoto.

It was long believed that this church was the one at Shijobomon, which was remodeled in 1578, and was the most famous of all the Jesuit buildings in Kyoto. However, Mr. Ichio Kuga has suggested that it was more likely to have been the church that was rebuilt on the northeastern side of the Ichijomodoribashi bridge during the Keicho era (1596-1614).

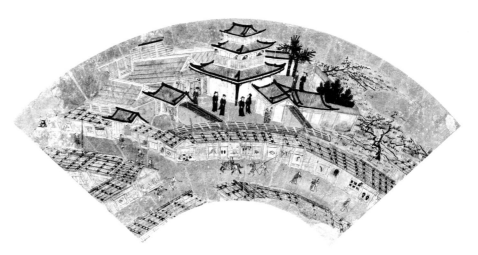

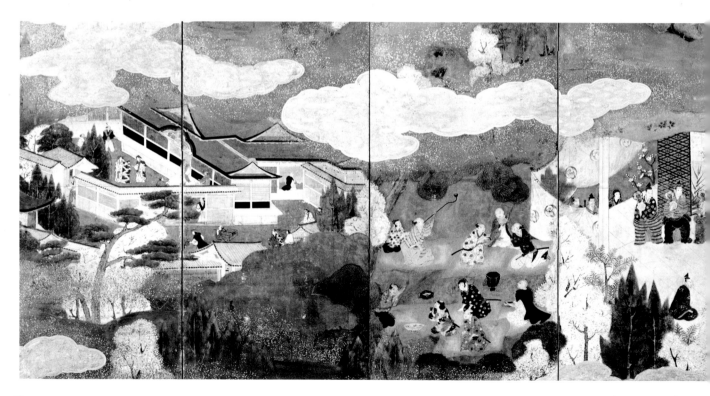

14. Spectators at a Nō Play

Late 16th-early 17th Century
Eight-fold screen, painted in color on paper
41⅞″ x 167⅝″ (106.5 cm x 425.8 cm)
Lent by Kobe City Museum of Namban Art

It is generally agreed that this painting represents a scene from a festival *Nō* play, staged as part of the entertainment planned for the visit of Emperor Goyozei at Jurakudai, the Palace of Pleasure which Toyotomi Hideyoshi built to display his power. It is not certain, however, that the painting was actually done in 1588, the year the Emperor was invited to the castle.

 The play being staged is *Okina,* and among the spectators are a *Namban-jin* (Westerner) and some people smoking. Tobacco, a new experience for the Japanese at that time, was apparently considered exotic.

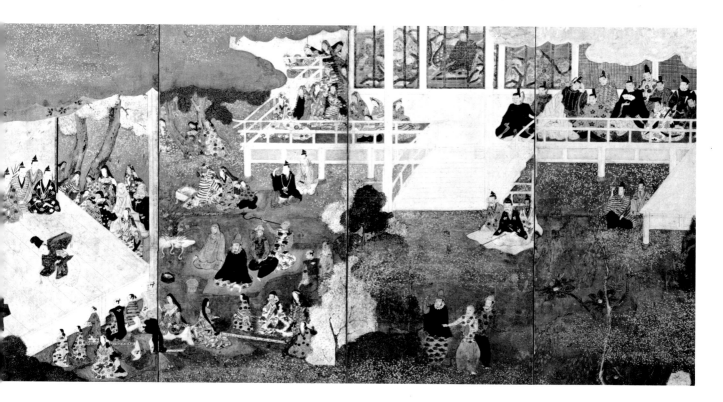

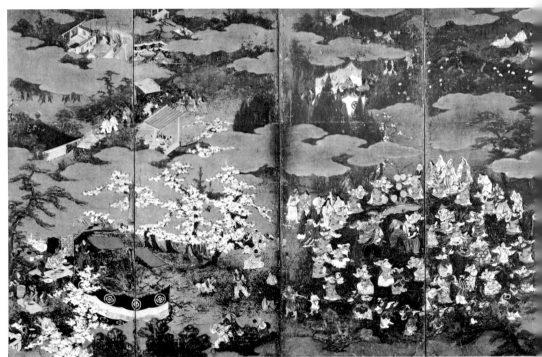

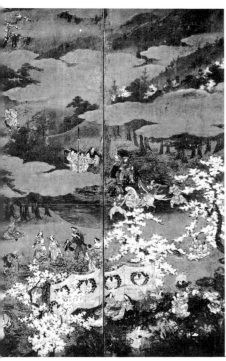

15. Group Dancing Beneath Cherry Blossoms

Late 16th Century

Pair of six-fold screens, painted in color on paper

58¾″ x 138⅞″ each (149.3 cm x 352.7 cm each)

Lent by Kobe City Museum of Namban Art

This painting has been tentatively attributed to Kano Hideyori.

 The center of the right half of the screen is occupied by two figures in *Namban* costumes dancing under a large umbrella; they are perhaps Japanese having fun in disguise. The group on the left half of the screen dances around two figures dressed to represent Ebisu and Daikoku, two of the seven gods of Good Fortune.

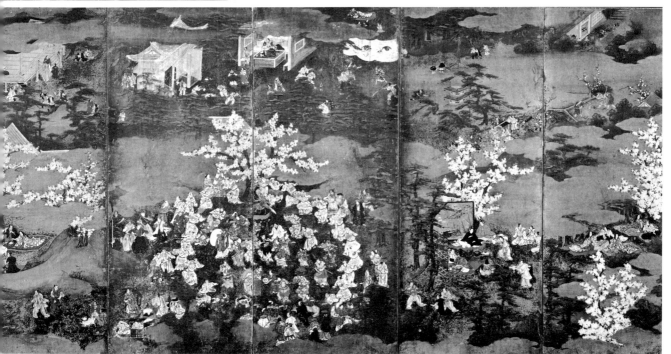

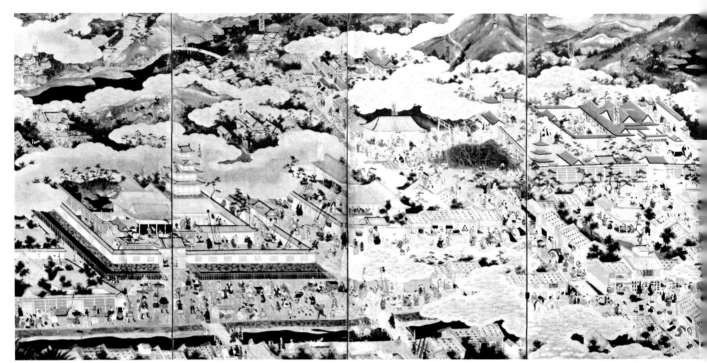

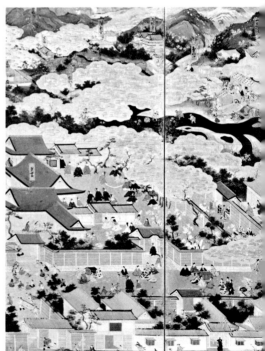

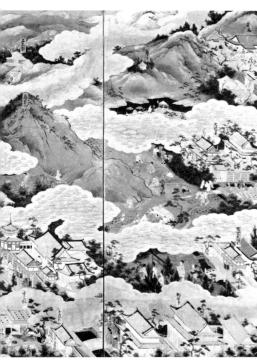

16. View of Kyoto

First half of 17th Century

Pair of six-fold screens, painted in color on gold-leafed paper

37″ x 107⅛″ each (94.1 cm x 272.0 cm each)

Lent by Namban Bunkakan, Osaka

A group of *Namban-jin* (Westerners) is approaching Nijo Castle in Kyoto.

The painting is possibly the work of a painter in the Kano school who was active during the Genna era (1615-23).

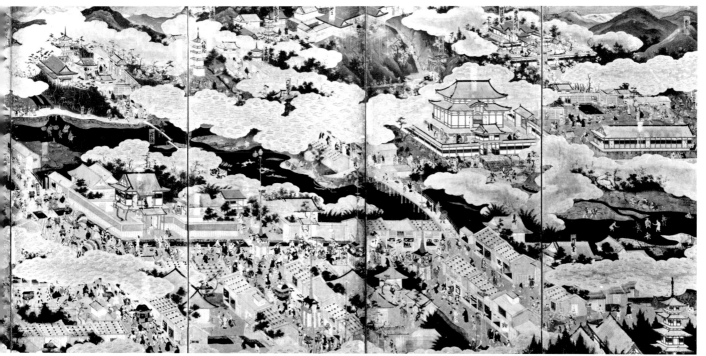

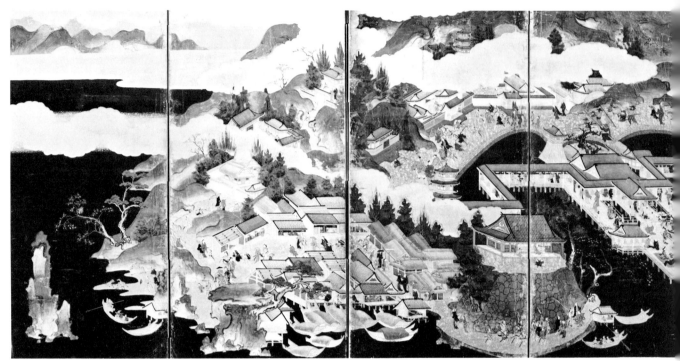

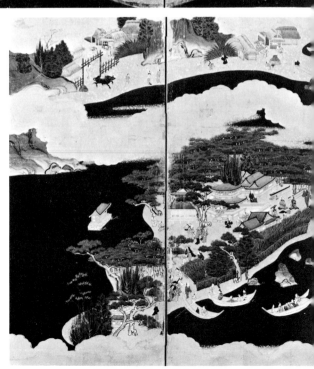

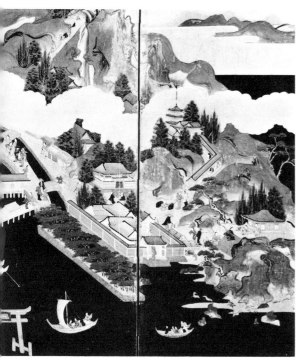

17. Itsukushima Shrine and Amanohashidate-inlet

17th Century

Pair of six-fold screens, painted in color on paper

36⅜″ x 106″ each (92.3 cm x 269.2 cm each)

Lent by Namban Bunkakan, Osaka

Some *Namban-jin* (Westerners) are recognizable behind the Itsukushima shrine. The painting is considered to have been done some time after the Kanei era (1624-43).

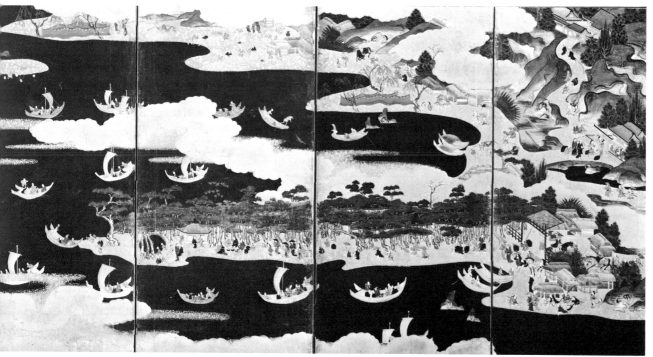

18. Japanese Trading with Foreigners

Middle 17th Century

Hanging scrolls, painted in color on paper

34⅛″ x 60¼″ each (86.6 cm x 152.9 cm each)

Lent by Kobe City Museum of Namban Art

It is thought that the three scrolls were originally part of a set of six panels. The site is obviously a port town, and *Namban-jin* (Westerners), Chinese and Japanese are busily engaged in various commercial transactions.

The style of painting differs distinctly from that found in the Namban screens made by painters of the Kano school. These scrolls have been attributed to Sumiyoshi Jokei.

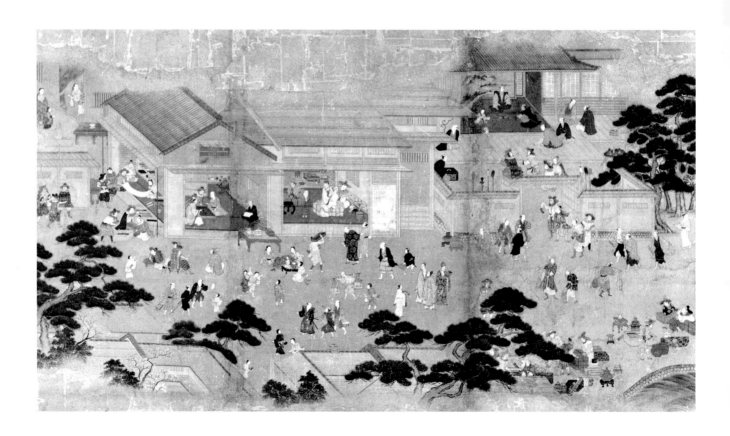

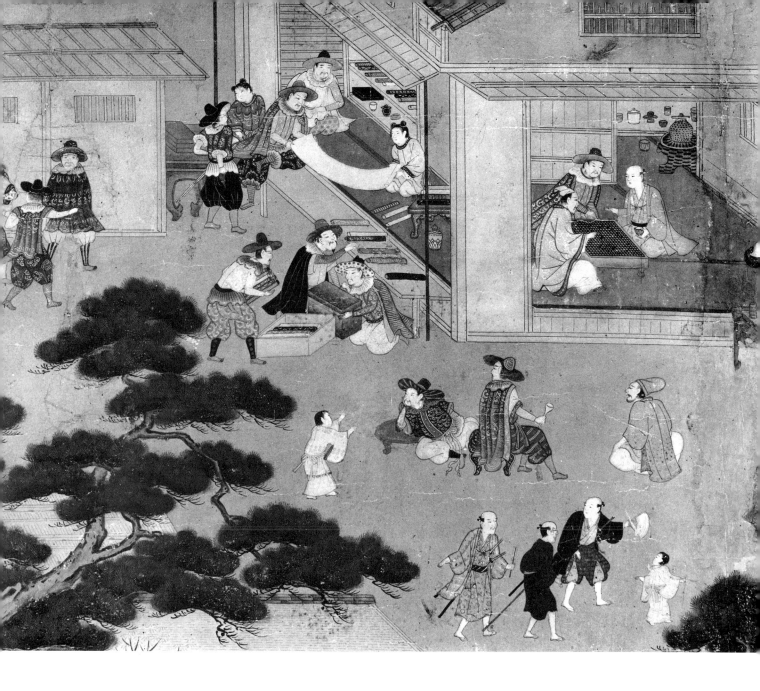

73

19. Portrait of Oda Nobunaga (With eulogistic inscription by the Priest Kokei dated 1583)

ca. 1583

Hanging scroll, painted in color on silk

28⅞″ x 14½″ (73.3 cm x 36.8 cm)

Registered as Important Cultural Property

Lent by Kobe City Museum of Namban Art

The inscription which appears above this portrait is by Kokei Sochin. In it, Sochin praises the subject, Nobunaga, who is shown in a formal court dress. Sochin, the 117th abbot of Daikokuji temple in Kyoto, was the first to be appointed chief priest of Soken-in when Toyotomi Hideyoshi built the ancillary temple in the Daitokuji compound in 1582 to commemorate Oda Nobunaga, his former commander.

 The portrait, prepared for the first anniversary of Nobunaga's death, is believed originally to have been owned by the Soken-in temple.

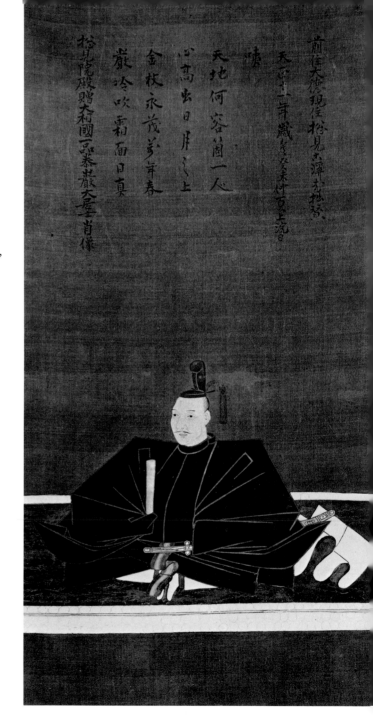

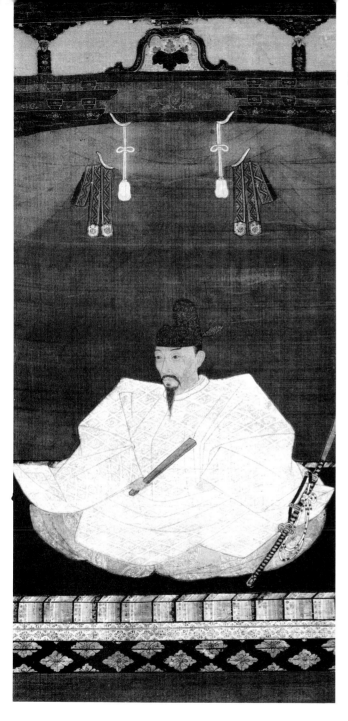

20. Portrait of Toyotomi Hideyoshi

Late 16th-early 17th Century

Hanging scroll, painted in color on silk

32⅛″ x 14½″ (81.6 cm x 36.9 cm)

Lent by Kobe City Museum of Namban Art

This portrait of Toyotomi Hideyoshi in a formal court dress is attributed to Kano Sanraku.

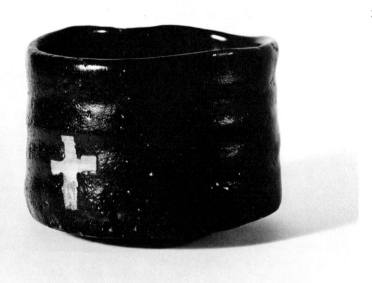

21. Tea Bowl Decorated with a Cross
Late 16th Century
Pottery: Mino-Seto ware, black Seto
Known as "Daidoji"
Diameter 4⅝"-5⅜"; Height 3⅞" (11.8 cm-13.8 cm; 9.7 cm)
Lent by Mr. Ichio Kuga, Osaka

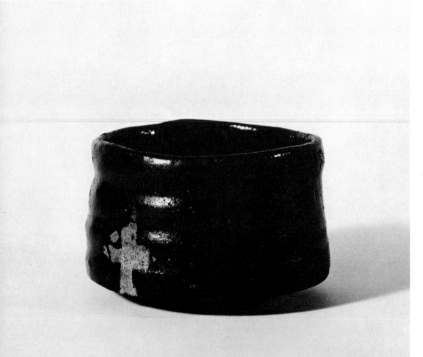

22. Tea Bowl Decorated with a Cross
Late 16th Century
Pottery: Mino-Seto ware, black Seto
Diameter 4⅝"-4⅞"; Height 3⅛" (11.9 cm-12.3 cm; 7.9 cm)
Lent by Mr. Ichio Kuga, Osaka

At the time when Christianity was introduced into Japan in the middle of the 16th century, the tea ceremony was already an ancient tradition. The Japanese converts, in their zeal for their new religion, began to decorate even their tea utensils with crosses. Not all crosses, however, should be interpreted as having a religious meaning; sometimes they only indicated the Japanese fascination with things that were foreign.

Black Seto ware was first produced during the Tensho era (1573-91) in Seto and Mino, but it is generally agreed that the best pieces were those made during the Bunroku era (1592-95) at Ogaya in Mino. Ogaya happened to be an area where Christians were very active.

23. Tea Bowl Decorated with a Cross
Early 17th Century
Pottery: Oribe ware, black glaze
Diameter 4½″- 4¾″; Height 3¼″ (11.5 cm-12.2 cm; 8.2 cm)
Lent by Mr. Ichio Kuga, Osaka

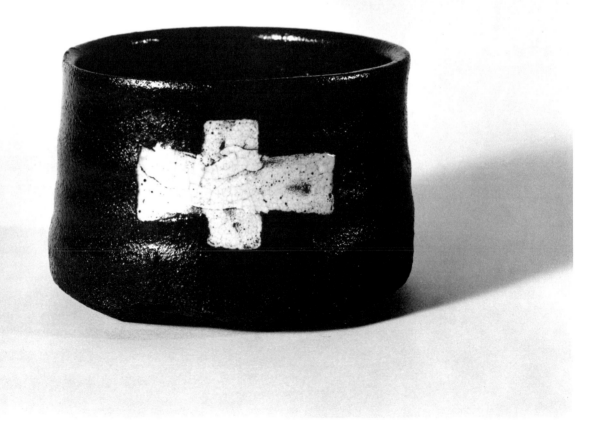

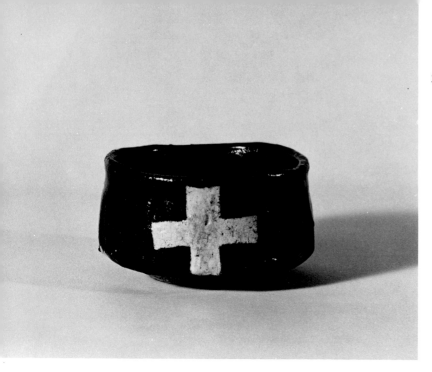

24. Tea Bowl Decorated with a Cross
Early 17th Century
Pottery: Oribe ware, black glaze
Diameter 4¼"; Height 2⅜" (10.8 cm; 5.9 cm)
Lent by Mr. Ichio Kuga, Osaka

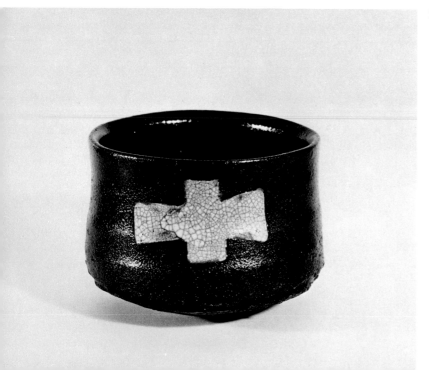

25. Tea Bowl Decorated with a Cross
Early 17th Century
Pottery: Oribe ware, black glaze
Diameter 4⅜"-4¾"; Height 3⅜" (11.2 cm-12.1 cm; 8.6 cm
Lent by Namban Bunkakan, Osaka

What is known as Oribe ware was first introduced by
Furuta Oribe (1544-1615), a master of the tea ceremony
Among Oribe's associates were many *daimyo* and practi
tioners of the tea ceremony who were deeply interested i
Christianity, which probably explains why Oribe liked t
use on his ware symbols associated with the Christian
religion.

26. Tea Bowl Decorated with Crosses

Early 17th Century
Pottery: Oribe ware, black glaze
Diameter 4⅛″-5¼″; Height 3″ (10.6 cm-13.3 cm; 7.8 cm)
Lent by Kobe City Museum of Namban Art

Engraved on the tea bowl are two crosses combined with
XP, the first letters in the Greek spelling of the word
"Christ." The work is attributed to Motozo, one of the ten
Seto potters approved by Oribe, the master of the tea
ceremony, and his school.

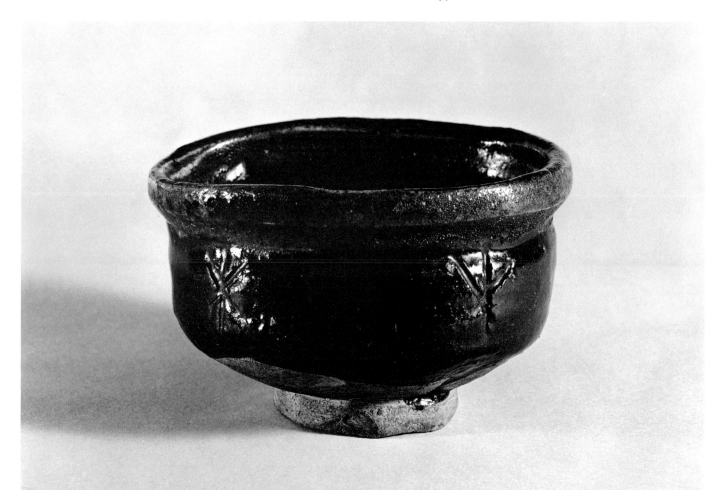

27. Candlestick in the Shape of a Foreign Priest
 Late 16th-early 17th Century
 Pottery: Oribe ware
 Height 11″ (28.0 cm)
 Lent by Mr. Ichio Kuga, Osaka

The base of the statue retains the marks of the thread—an indication that the potter's wheel was used. The body was built by coiling up clay and when the figure is finished, it received a yellowish-brown and verdigris glaze, like yellow Seto ware.

A fragment of a candlestick in which the figure holds the candle in his left hand, and which is almost identical with this one, has been found at an abandoned kiln (Yueomon's) in Ogaya, Mino.

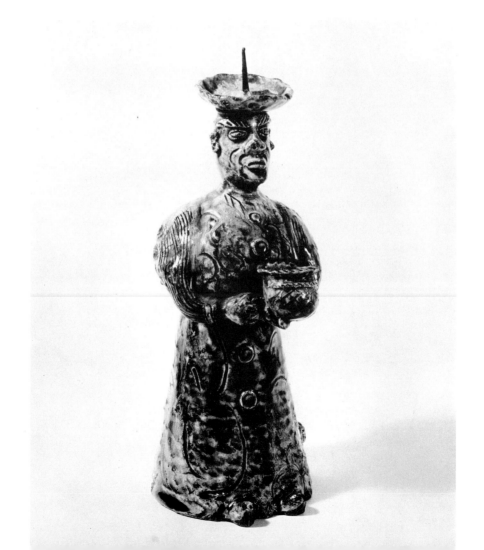

28. Holy Water Container with Lid in the Form of a Mokko Cross, Decorated with a Cross

Late 16th-early 17th Century

Pottery

Diameter 8¼″; Height 7″ (21.1 cm; 17.6 cm)

Lent by Mr. Ichio Kuga, Osaka

The term *"mokko"* denotes a traditional Japanese design, which is derived from flower petals, and is used for heraldic crests. Similar flower-petal patterns are frequently found in European paintings. In its simplest form the *mokko* may consist of four petals which form a cross, and is then known as *"juji-mokko"* or *"cross-mokko."* The latter was probably created by Japanese Christians, as it represents a blend of both European and Japanese traditions, and was used by them in the decoration of religious objects.

Some of the sword guards made under the auspices of the Hosokawa family in Kyushu also carry this pattern.

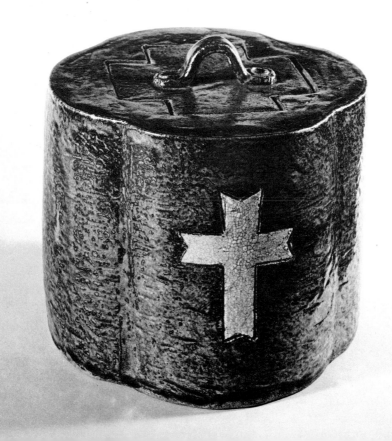

29. Water Jar in the Shape of a Cross

Late 16th-early 17th Century

Pottery: Shino ware

Diameter 7⅜″; Height 6¾″ (18.8 cm; 17.0 cm)

Lent by Mr. Ichio Kuga, Osaka

The beautiful texture of this jar is the result of the generous application of feldspar to the glaze, typical of Shino ware. The jar may well belong to a class of pottery known as Shino-Oribe. Inscribed on the cross at the bottom is the potter's name, Motoetsu.

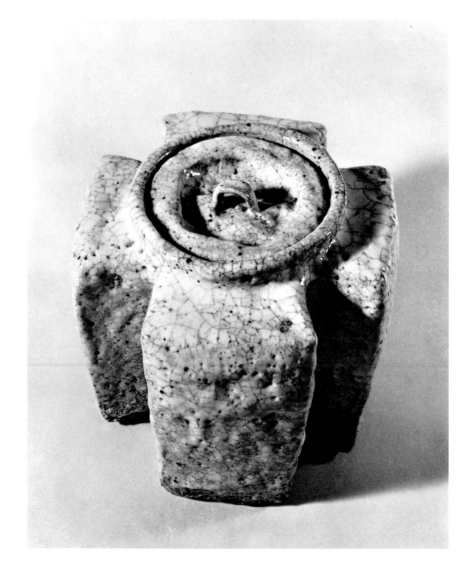

30. Large Jar with Figures of Foreigners
Early 17th Century
Pottery: Karatsu ware
Diameter of mouth 8⅝″; Height 9⅝″ (21.9 cm; 24.5 cm)
Lent by Mr. Ichio Kuga, Osaka

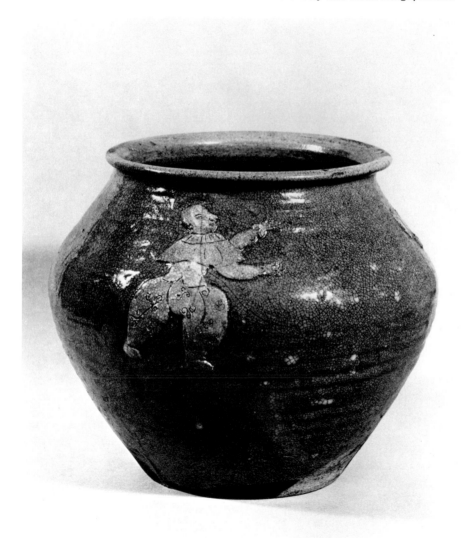

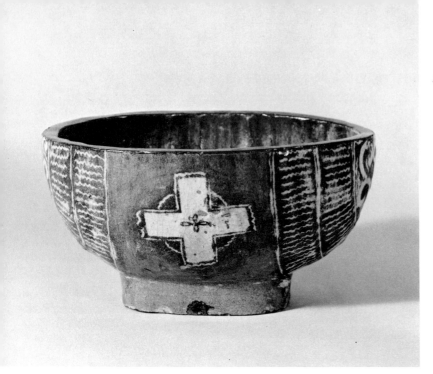

31. **Bowl Decorated with a Cross**
Early 17th Century
Pottery
Diameter 6⅛"-8"; Height 4" (15.6 cm-20.2 cm; 10.3 cm
Lent by Kobe City Museum of Namban Art

32. **Bowl Decorated with a Cross**
First half of 17th Century
Pottery: Hagi ware
Diameter 6¾"-7½"; Height 5" (17.2 cm-18.9 cm; 12.8 cr
Lent by Mr. Ichio Kuga, Osaka

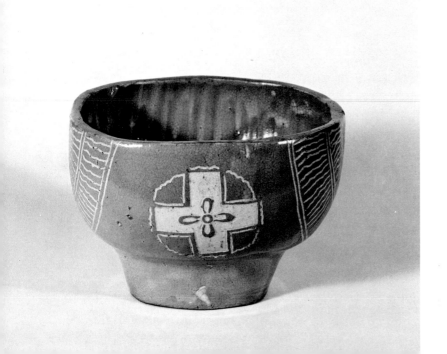

33. Bowl Decorated with Flowers and a Cross
Mid-17th Century
Pottery: Hanamishima-type
Diameter 5⅝"-7"; Height 4⅝" (14.9 cm-17.6 cm; 11.7 cm)
Lent by Mr. Ichio Kuga, Osaka

The actual use of these bowls remains unknown, though it is possible that they were used by Christians as holy water containers. These shapes and patterns are unique in the history of Japanese pottery.

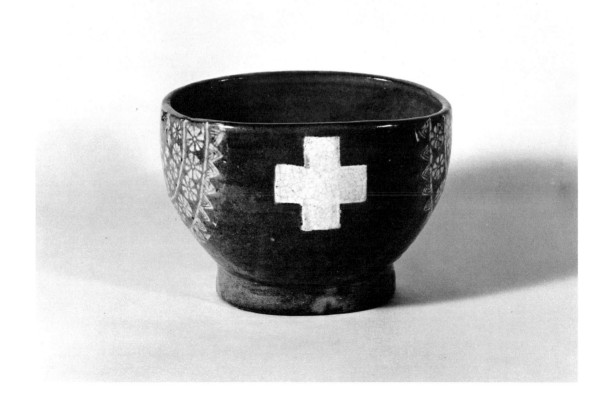

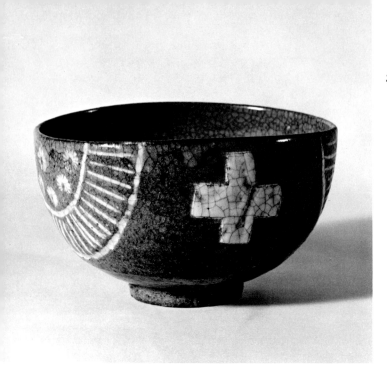

34. Tea Bowl with Cross and Flower Design
Mid-17th Century
Pottery: Hanamishima-type
Diameter 4¾″-5⅜″; Height 3″ (12.0 cm-13.7 cm; 7.7 cm)
Lent by Mr. Ichio Kuga, Osaka

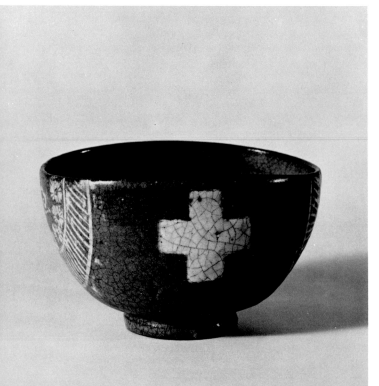

35. Tea Bowl with Cross and Flower Design
Mid-17th Century
Pottery: Hanamishima-type
Diameter 4″-5″; Height 3″ (10.0 cm-12.5 cm; 7.5 cm)
Lent by Mr. Ichio Kuga, Osaka

Bowls with designs similar to No. 31, No. 32 and No. 33 were later reduced in size and came to be used as tea bowls.

36. Hexagonal Sake Bottles with Figures of Foreigners
Mid-17th Century
Pottery: Old Kiyomizu ware, colored glaze
Diameter 3⅛″; Height 9¾″ (7.8 cm; 23.7 cm)
Lent by Mr. Ichio Kuga, Osaka

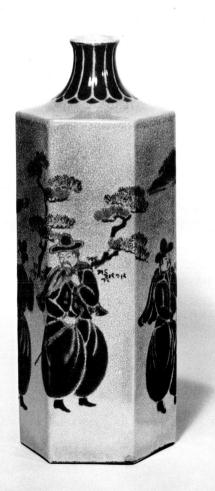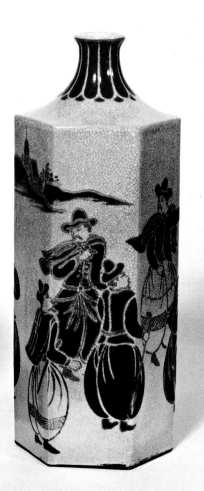

37. Bottle for Holy Water with Jesuit Crest
17th Century
Pottery: Seto ware, blue and white glaze
Diameter 3⅝″; Height 4″ (9.8 cm; 10.1 cm)
Lent by Namban Bunkakan, Osaka

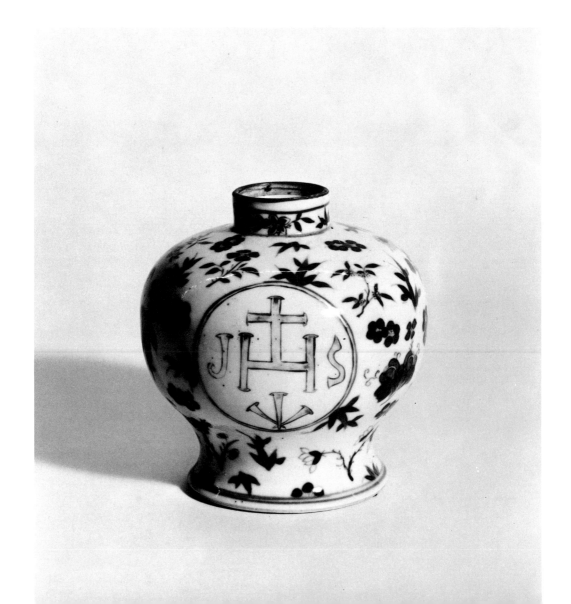

38. Box for Communion Wafers with Ivy Design and Jesuit Crest

Late 16th-early 17th Century
Gold lacquer with mother-of-pearl inlay
Diameter 4⅜″; Height 3⅝″ (11.2 cm; 9.3 cm)
Lent by Namban Bunkakan, Osaka

Similar boxes for the wafers used in the Catholic ritual of communion are owned by Tokei temple in Kamakura, the Tokugawa family in Mito and the Itsuo Museum in Ikeda, Osaka.

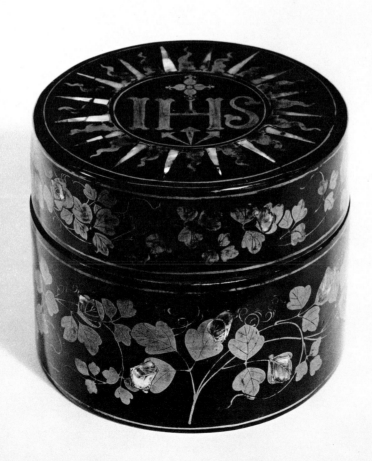

39. Coffer Decorated with Plants and Animals

Early 17th Century

Gold lacquer with mother-of-pearl inlay

Length 31½″; Width 17⅝″; Height 21″ (80.0 cm; 44.8 cm; 53.5 cm)

Lent by Namban Bunkakan, Osaka

From the late 16th to the early 17th centuries, a great quantity of what is known as *Namban* lacquer ware was produced for domestic and export purposes, mainly in Kyoto. Many such lacquer-ware pieces that went abroad are still found in museums and private collections in various parts of Europe. In recent years some of them have been brought back to Japan. This particular coffer came recently from London.

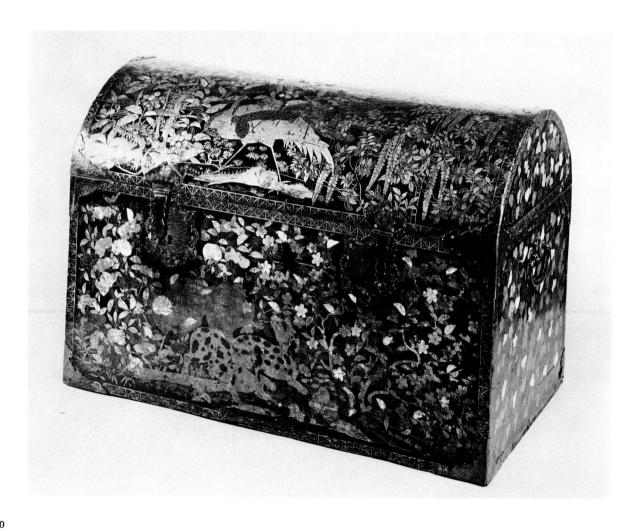

40. Casket Decorated with a Cross

Early 17th Century

Gold lacquer with mother-of-pearl inlay on wood

Length 6½″; Width 3⅝″; Height 4⅛″ (16.6 cm; 9.2 cm; 10.4 cm)

Lent by Namban Bunkakan, Osaka

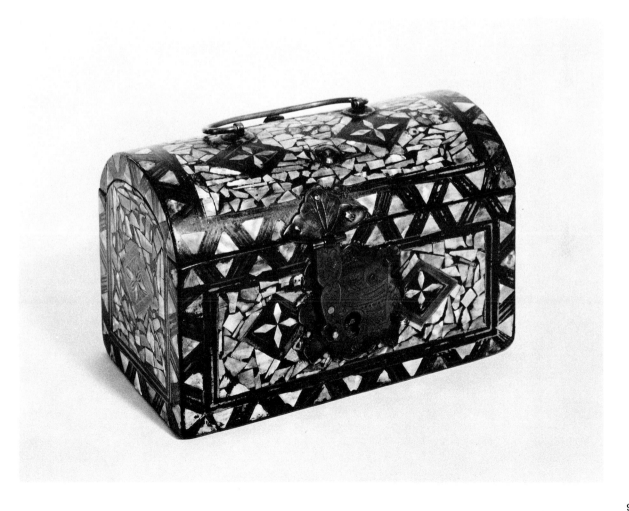

41. Cabinet with Figures of Round Crests

Early 17th Century

Lacquer, mother-of-pearl inlay on wood

Length 27″; Width 15⅛″; Height 19¾″ (68.5 cm; 38.4 cm; 50.3 cm)

Lent by Namban Bunkakan, Osaka

A round crest design similar to this one decorates the coffer in the collection of Isabella Stewart Gardner Museum in Boston. Prof. Boyer says that the coffer was made in 1606. This chest most likely was made about the same time.

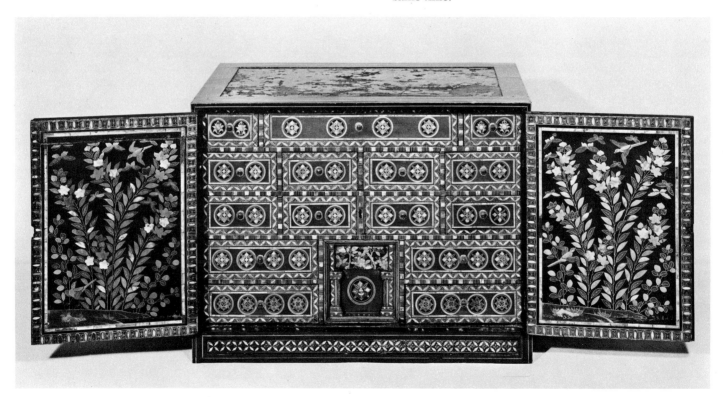

42. Backgammon Board Decorated with Scattered Fans

Early 17th Century

Gold lacquer with mother-of-pearl inlay on wood

Length 12⅜″; Width 21⅛″ Height 3½″ (31.5 cm; 53.6 cm; 8.9 cm)

Lent by Namban Bunkakan, Osaka

This backgammon board was probably commissioned by a European. Like the coffer (No. 39 in this exhibition) it was recently acquired in Europe for a Japanese museum.

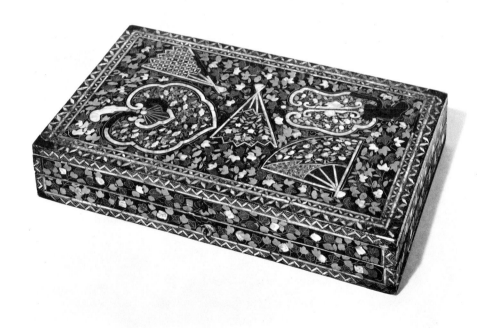

43. Writing Box with Figures of Foreigner and Dog
Early 17th Century
Gold lacquer on wood
Length 8¼″; Width 8⅝″; Height 1⅝″ (20.9 cm; 22.0 cm; 4.1 cm)
Lent by Kobe City Museum of Namban Art

44. Writing Box with Figure of Foreigner

Early 17th Century

Gold lacquer on wood

Length 3⅜″; Width 8⅜″; Height 1½″; (8.7 cm; 20.7 cm; 4.0 cm)

Lent by Kobe City Museum of Namban Art

45. Writing Box Decorated with Crown and Cross

Early 17th Century

Black lacquer, inlaid with tin

Length 8⅜″; Width 12″; Height 2″ (21.2 cm; 30.3 cm; 5.1 cm)

Lent by Kobe City Museum of Namban Art

46. Writing Box with Jesuit Crest

Early 17th Century

Gold lacquer

Length 6⅞″; Width 7⅛″; Height 1¼″ (17.4 cm; 18.2 cm; 3.1 cm)

Lent by Namban Bunkakan, Osaka

This writing box, belonging to a family related to Owari Ichinomiya, was first shown to the public in 1949 at an exhibition held to commemorate the 400th anniversary of St. Francis Xavier's visit to Japan. On the front of the lid is a design combining the crest of the Jesuit Society and ivy, and on the back, a clock face patterned after the Chinese zodiac. According to family records of the former owner, it was once owned by Oda Hidenobu, a *daimyo* who converted to Christianity, but the more likely explanation is that it belonged to a church in Gifu.

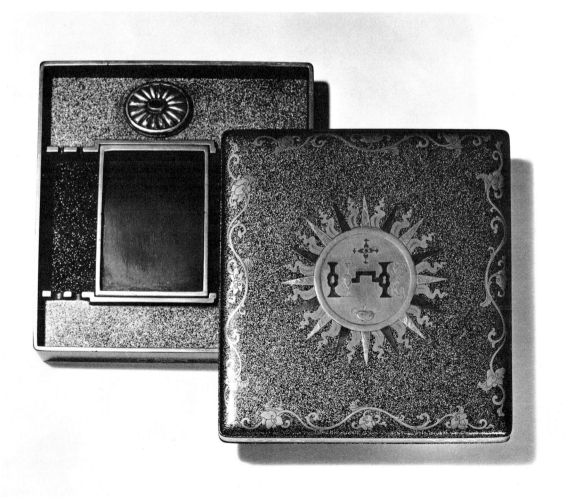

47. Saddle with Figures of Foreigners and Dogs
Early 17th Century
Lacquered
Height 11⅜″ (27.8 cm)
Lent by Namban Bunkakan, Osaka

The back of the saddle bears the signature of Maeda
Ietsugu, and his cipher is inscribed in black lacquer.

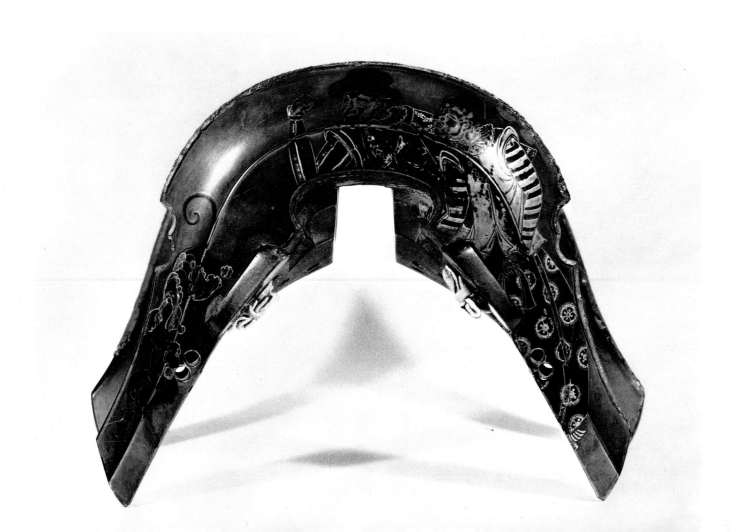

48. Saddle with Figures of Foreigners

Early 17th Century
Gold lacquer
Height 10¾″ (27.4 cm)
Lent by Kobe City Museum of Namban Art

On the back of the saddle is inscribed: "A good day in July in the ninth year of Keicho (1604). Made by Izeki Tsukuyuki at Kitanosho, Esshu."

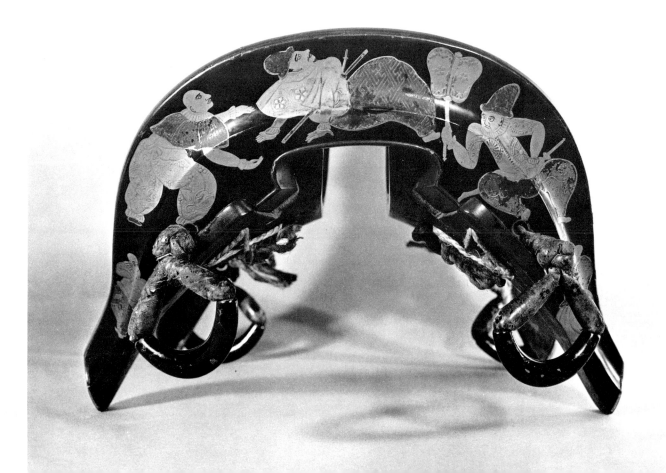

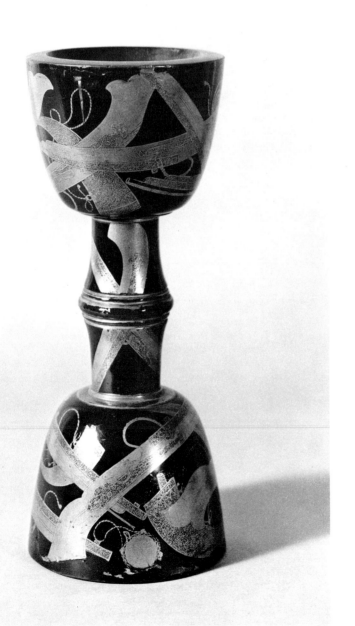

49. Lacquered Drum with Design of Matchlock Guns
Early 17th Century
Gold lacquer
Diameter at end 4⅜″: Height 11⅜″ (11.1 cm; 27.8 cm)
Lent by Kobe City Museum of Namban Art

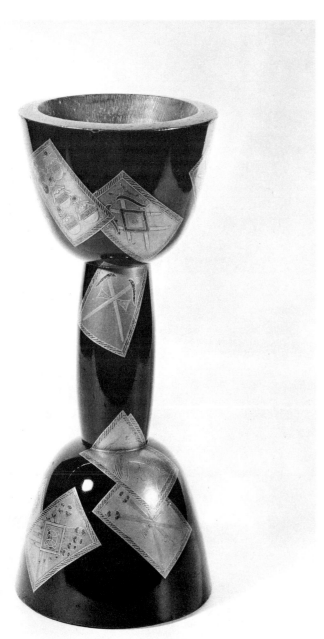

50. Lacquered Drum with Design of Western Playing Cards

Early 17th Century
Gold lacquer on wood
Diameter at end 4″; Height 9⅞″ (10.2 cm; 25.1 cm)
Lent by Namban Bunkakan, Osaka

During the Tensho era (1573-91) the playing of a Portuguese card game called *Carta* became popular. The cards used were known as *un sun carta*. They were printed from wooden blocks made by Japanese craftsmen, after Portuguese models. At a later time these cards in the Japanese design.

The popularity of playing cards is reflected in their use as a decorative motif, e.g. on the trays described in No. 54 and especially on the wooden box, No. 55, which is constructed out of wooden blocks used for printing the cards.

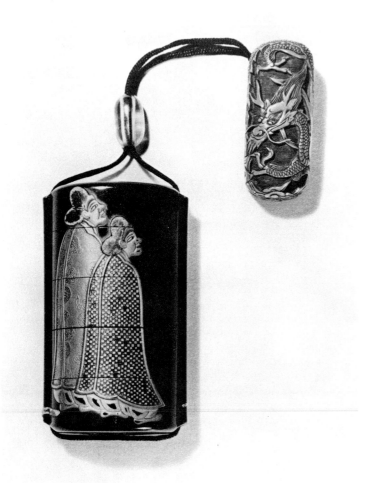

51. Medicine Case (inro) with Figures of Foreigners
Late 17th Century
Lacquer on wood
Length 2″; Width 3⅜″ (5.0 cm; 8.5 cm)
Lent by Namban Bunkakan, Osaka

On the bottom of the *inro* is written: "Tsuchida Soetsu. Seventy-seven years old" with his cipher. Soetsu was a well-known lacquer artist who was active in Kyoto during the Genroku era (1688-1703).

It may be worth noting that the *Namban-jin* (Westerner.) painted on the *inro* has a striking resemblance to the figure painted on the left half of the Namban Screens in the collection of the Imperial Household (Special Item No. 1.)

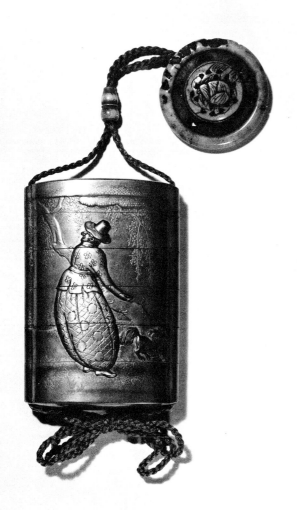

52. Medicine Case (inro) with Figures of Foreigner and Dog
Early 19th Century
Lacquer on wood
Length 2⅞″; Width 4⅛″ (7.2 cm; 10.5 cm)
Lent by Namban Bunkakan, Osaka

The *inro* has the name of Koma Kansai. The *Namban-jin* (Westerner) painted on the *inro* looks exactly like the figure on the right half of the Namban Screen (65.22) in the collection of the Freer Gallery of Art in Washington, D.C.

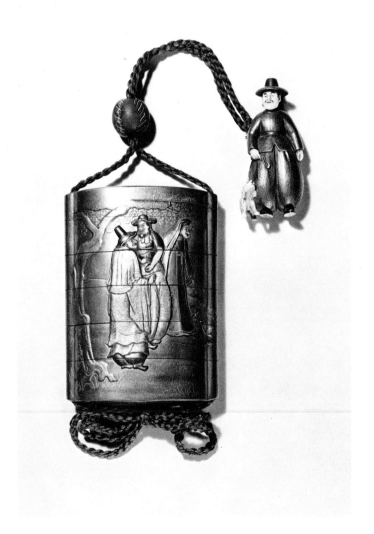

53. Medicine Case (inro) with Figures of Foreigners

Early 19th Century
Lacquer on wood
Length 2⅞″; Width 4″ (7.2 cm; 10.0 cm)
Lent by Namban Bunkakan, Osaka

On the bottom is written: "Made by Kofu." As in No. 52, the *Namban-jin* (Westerner) painted on this *inro* looks exactly like the figure on the right half of the Namban Screen (65.22) in the collection of the Freer Gallery of Art in Washington, D.C.

54. Trays with Design of Western Playing Cards

17th Century

Set of four, gold lacquer on wood

Length 3⅜″; Width 4½″; Height 1″ each (8.5 cm; 11.4 cm; 2.7 cm each)

Lent by Kobe City Museum of Namban Art

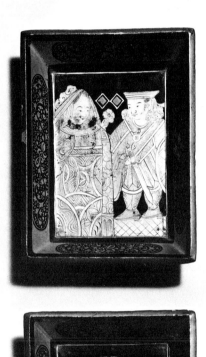

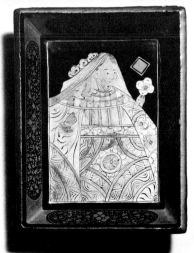
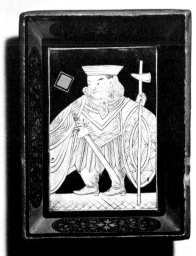

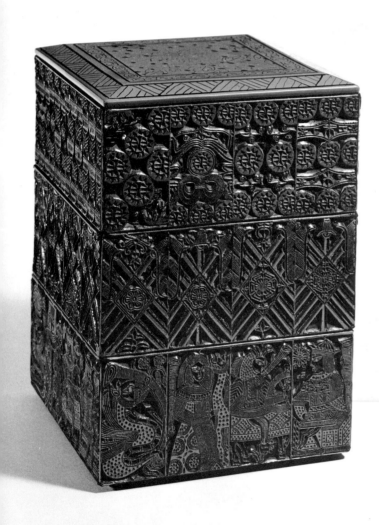

55. Box Made From Blocks used for Printing of Western Playing Cards

17th Century

Engraved wood

Length 5¾"; Width 5¾"; Height 8⅛" (14.5 cm; 14.5 cm; 20.8 cm)

Lent by Kobe City Museum of Namban Art

This box is constructed out of wooden blocks that had previously been used to print playing cards of the Western type. Each side consists of three tiers composed of four blocks, making a total of 48.

56. Crucifix

Early 17th Century
Cloisonné
Length 8⅛"; Width 4⅝" (20.7 cm; 12.2 cm)
Lent by Mr. Ichio Kuga, Osaka

The base of this crucifix is brass. The figure of Christ occupies the upper portion, and the chalice the center; there are grapes on the left and ears of corn on the right; drawn at the bottom are the crown of thorns and the three nails. The letters on the upper part, INRI, stand for Iesus Nazarenus Rex Iudeorum; the design filling the remaining space is what is traditionally known as *karakusa,* an arabesque.

At the tip of the left arm of the cross are a sword, hammer and pliers; at the tip of the right arm, a scourge, ladder and a pole with a sponge at its end. All these objects refer to the Passion of Christ.

The base glaze of opaque white is overlaid with yellow, red, purple and green. The cross is an excellent example of the technique known as *shippo* (cloisonné).

57. Crown-Shaped Incense Burner with Cross Design
Early 17th Century
Gold and copper
Height 28″ (73.5 cm)
Lent by Mr. Ichio Kuga, Osaka

58. Stirrups with Design Depicting the Passion of Christ

Early 17th Century
Pair, metal
Height 8⅞″; Width 5″ each (22.5 cm; 12.5 cm each)
Lent by Namban Bunkakan, Osaka

These stirrups are of unusual interest for their detailed representation of the emblems of the Passion of Christ, known as the Arma Christi, inlaid with silver and brass. These include a cross, crown of thorns, ladder, hammer, pliers, the pillar at which Christ was scourged, the cock, the veil of Veronica, a spear, a pole with a sponge, a scourge, dice, the hand of Judas gripping the leather bag filled with silver coins, and St. Peter's sword.

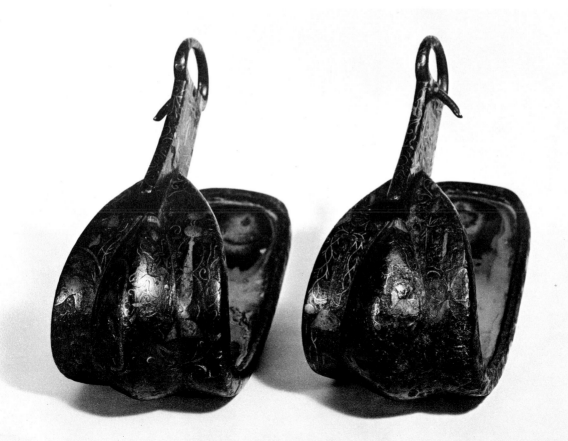

59. Stirrups with Figures of Foreigners
Early 17th Century
Pair, metal
Height 10⅛″; Width 5½″ each (25.8 cm; 14.1 cm each)
Lent by Kobe City Museum of Namban Art

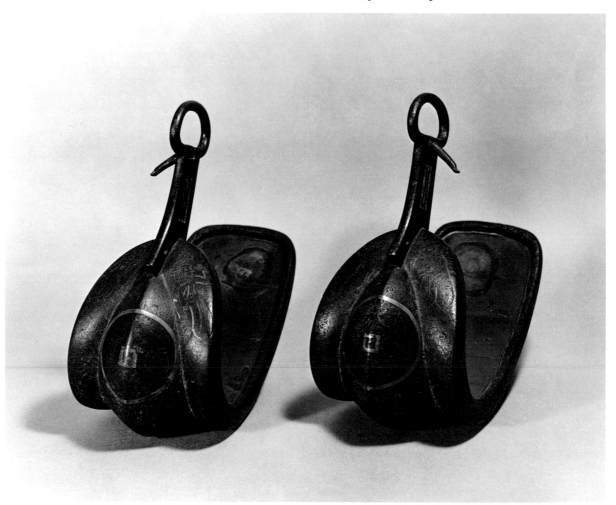

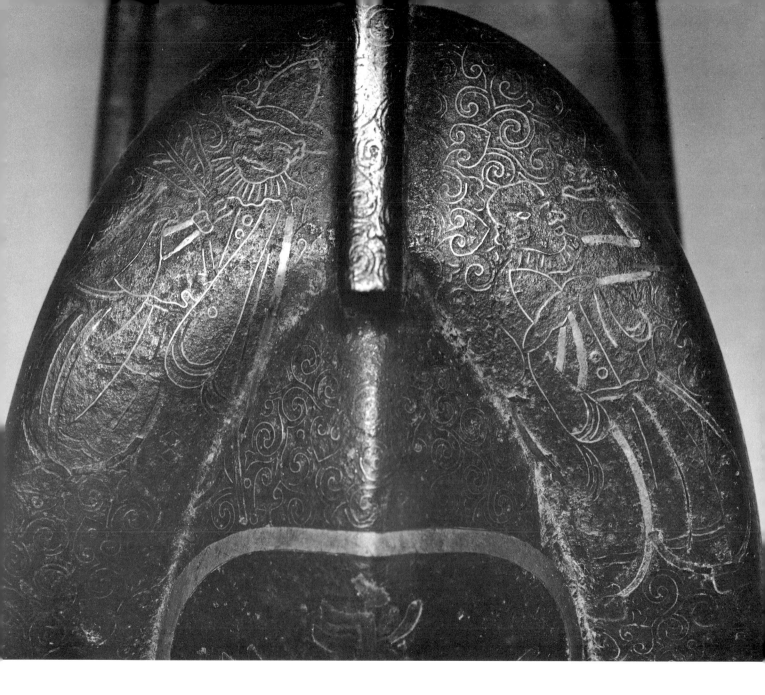

60. Hand Brazier with Figures of Foreigners
 17th Century
 Metal
 Width 11¼″; Height 6¾″ (28.7 cm; 17.2 cm)
 Lent by Namban Bunkakan, Osaka

61. Eight-pointed Mirror with Figure of Strolling Foreigner
17th Century
Bronze
Diameter 5⅛″ (13.1 cm)
Lent by Kobe City Museum of Namban Art

62. Hand Mirror with Figures of Two Strolling Foreigners
17th Century
Bronze
Diameter 3⅞″; Length 3⅞″ (9.9 cm; 10.0 cm)
Lent by Kobe City Museum of Namban Art

63. Hand Mirror with Figure of Smoking Foreigner
17th Century
Bronze
Diameter 3⅞″; Length 4″ (9.8 cm; 10.1 cm)
Lent by Kobe City Museum of Namban Art

64. Sword Guard, Knife and Hairpin Decorated with Maltese Crosses

Late 16th-early 17th Century

Iron

Diameter of sword guard 2¾″-3″; Length of knife 3¾″;
Length of hairpin 8⅜″ (7.0 cm-7.5 cm; 9.6 cm; 21.2 cm)

Lent by Mr. Ichio Kuga, Osaka

These items are believed to have been owned by Nose Yoritsugi (1563-1625), a Christian *daimyo*. Nose, who was from the Nose area of Settsu, is believed to have used the Maltese Cross as his family crest while he was a Christian, and to have called the same crest "*yahazu juji*" (literally, "cross with the notched end of an arrow") after his conversion to the Nichiren sect of Buddhism.

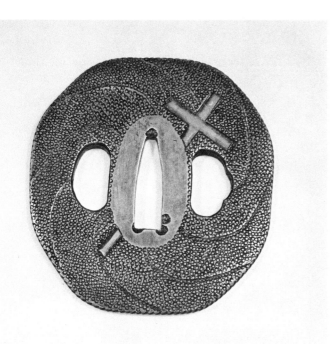

65. Sword Guard Decorated with a Latin Cross
Late 16th-early 17th Century
Brass
Diameter 2⅞″-3″ (7.2 cm-7.5 cm)
Lent by Mr. Ichio Kuga, Osaka

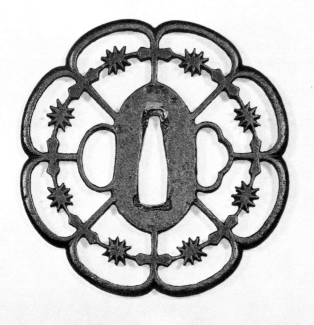

66. Sword Guard with Star-Shaped Cross Design
Late 16th-early 17th Century
Iron
Diameter 3⅛″ (8.0 cm)
Lent by Mr. Ichio Kuga, Osaka

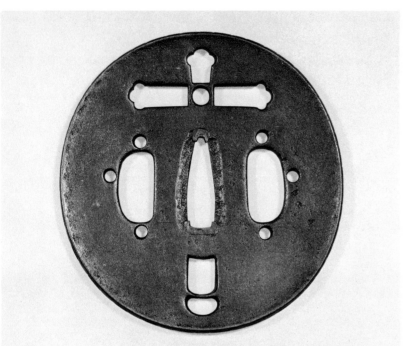

67. Sword Guard Decorated with a Latin Cross
Early 17th Century
Iron
Diameter 3¼″-3⅜″ (8.4 cm-8.6 cm)
Lent by Mr. Ichio Kuga, Osaka

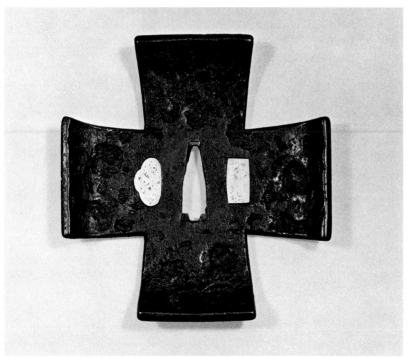

68. Cross-Shaped Sword Guard
Early 17th Century
Iron
Length 4″; Width 4⅛″ (10.2 cm; 10.5 cm)
Lent by Mr. Ichio Kuga, Osaka

69. Sword Guard with Open-work Cross and Curvilinear Design
Early 17th Century
Iron
Diameter 3⅝″ (9.1 cm)
Lent by Mr. Ichio Kuga, Osaka

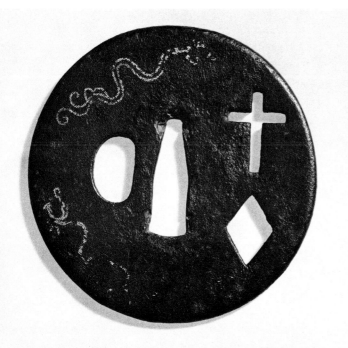

70. Sword Guard with Cross and Dragons
Early 17th Century
Gold inlay on iron
Diameter 3⅛″ (7.9 cm)
Lent by Kobe City Museum of Namban Art

71. Cross-Shaped Sword Guard with Design of Letters and Dragon in Relief
17th Century
Gold inlay on iron
Length 2½″; Width 2⅜″ (6.3 cm; 5.9 cm)
Lent by Kobe City Museum of Namban Art

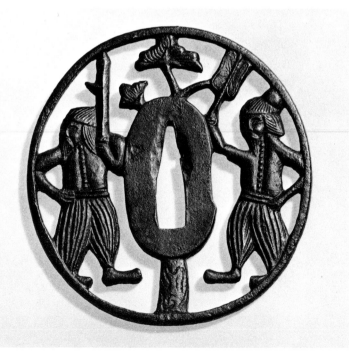

72. Sword Guard with Figures of Foreigners in Openwork Design
17th Century
Iron
Diameter 3⅛″ (7.9 cm)
Lent by Kobe City Museum of Namban Art

73. Sword Guard with a Foreign Ship in Openwork Design
17th Century
Gold inlay on iron
Diameter 2½"-2¾" (6.2 cm-7.0 cm)
Lent by Kobe City Museum of Namban Art

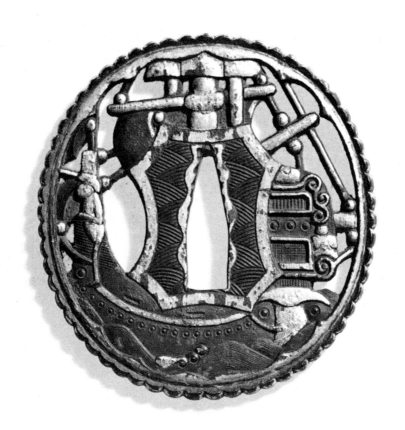

74. Matchlock Gun with Inlaid Initials "IHS"

First half of 17th Century
Wood and iron
Length 44⅛″ (112.1 cm)
Lent by Namban Bunkakan, Osaka

Guns were first introduced to Japan by the Portuguese, who reached Tanegashima, an island south of Kyushu, in 1543. The new weapon was soon in great demand among the *daimyo,* who were constantly warring against each other, and production began in various parts of Japan.

This particular matchlock was recently acquired in Madrid. Its tube support is beautifully inlaid with designs of dragons and *karakusa,* an arabesque. IHS, the crest of the Jesuit Society, is embossed with a decoration of *karakusa.*

BIBLIOGRAPHY

Benedict, Ruth Fulton. *The Chrysanthemum and the Sword*. London, 1947.

Boxer, Charles Ralph. *The Christian Century in Japan, 1549-1650*. Berkeley, 1967.

Boxer, Charles Ralph. *Fidalgos in the Far East. 1550-1770: Fact and Fancy in the History of Macao*. The Hague, 1948.

Boxer, Charles Ralph. *The Great Ship from Amacon: Annals of Macao and the Old Japan Trade, 1555-1640*. Lisbon, 1963.

Cartas que os Padres e Irmãos da Companhia de Jesus Escreverão dos Reynos de Iapão e China aos a mesma Companhia da India e China desdo anno de 1549 ate o de 1580. Evora, *1598*.

Cooper, Michael S. J., ed. *The Southern Barbarians: The First Europeans in Japan*. Tokyo and Palo Alto, California, 1971.

Cooper, Michael S. J., ed. *They Came to Japan: An Anthology of European Reports on Japan, 1543-1640*. Berkeley and London, 1965.

Duus, Peter. *Feudalism in Japan*. Knopf, 1969.

Frois, Luis S. J. *Die Geschichte Japans, 1549-1578*, eds. Georg Schurhammer, S. J. and E. A. Voretzch, Leipzig, 1926.

Frois, Luis S. J. *La Prèmiere Ambassade du Japon en Europe, 1582-1592*, eds. J. A. Abranches Pinto. Y. Okamoto and Henri Bernard, S J. (*Monumenta Nipponica* Monograph No. 6), Tokyo, 1942.

Frois, Luis S. J. *Segunda Parte da Historia de Japam, 1578-1582*, eds. J. A. Abranches Pinto and Y. Okamoto, Tokyo, 1938.

de Guzmann, Luis S. J. *Historia de las Misiones que han hecho los Religiosos de la Compania de Jesus para predicar el Sancto Evangelio en la India Oriental, y en los Reyons de la China y Japon*. Alcalá, 1601.

Lach, D. F. *Asia in the Making of Europe*. 2 vols., Chicago, 1965-70.

Laures, Johannes S. J. *Kirishitan Bunko* (A manual of books and documents on the early Christian mission in Japan). *Monumenta Nipponica* Monograph No. 5), 3rd ed., Tokyo, 1957.

McCall, J. E. "Early Jesuit Art in the Far East" in *Artibus Asiae*, X-XI, Dresden, 1947-48.

Tamon, Miki. "The Influence of Western Culture on Japanese Art," in *Monumenta Nipponica*, XIX, Tokyo, 1964.

Morris, Ivan I. *World of the Shining Prince: Court Life in Ancient Japan.* New York, 1964.

Pagès, Léon. *Histoire de la Religion Chrétienne au Japon depuis 1598 jusqu'à 1651.* 2 vols. Paris, 1869-70.

Purchas, Samuel. *Purchas, His Pilgrimes in Japan,* ed. Cyril Wild, Kobe, 1939.

Reischauer, Edwin O. *Japan, Past and Present.* New York, 1964.

Roberts, P. G. *The First Englishman in Japan.* London, 1956.

Rodrigues, João S. J. *Histório da Igreja do Japão,* 2 vols., ed. J. A. Abranches Pinto, Macao, 1954-56.

Sansome, Sir George Bailey. *A History of Japan, 1334-1615.* London, 1961.

Sansome, Sir George Bailey. *The Western World and Japan: Study in the Interaction of European and Asiatic Cultures.* New York, 1949.

Schurhammer, Georg S. J. "O descobrimento do Japão pelos Portugueses no Ano de 1543" in *Gesammelte Studien, II, Orientalia,* Lisbon and Rome, 1963.

Schurhammer, Georg S. J. *Franz Xaver, Sein Leben und seine Zeit,* 2 vols., Freiburg i. B., 1959.

Schütte, Josef Franz S. J. *Introductio ad Historiam Societatis Jesu in Japonia, 1549-1650.* Rome, 1968.

Schütte, Josef Franz S. J. *Valignanos Missionsgrundsätze für Japan.* 2 vols., Rome, 1951-58.

Uyttenbroeck, Thomas O.F.M. *Early Franciscans in Japan.* Himeji, 1959.

Valignano, Alessandro S. J. *Sumario de las Cosas del Japon, 1583,* ed. Jose Luis Alvarez-Taladriz *(Monumenta Nipponica* Monograph, No. 9) Tokyo, 1954.

Xavier, Francisco, S. J. *Epistolae S. Francisci Xaverii,* 2 vols., eds. G. Schurhammer, S. J., and J. Wicki, S. J., Rome, 1944-45.

Anesaki, Masaharu. *Kirishitan Dendo no Kohai* (The rise and fall of Christian missionary activities in Japan). Tokyo: Dobunkan, 1930.

Anesaki, Masaharu. *Kirishitan Shumon no Hakugai to Sempuku* (The suppression of Christians and their underground activities in Japan). Tokyo: Dobunkan, 1925.

Arakawa, Hirokazu. *Namban Shitsugei* (Namban lacquer art). Tokyo: Bijutsu Shuppansha, 1971.

Ebisawa, Arimichi. *Kirishitan Shi no Kenkyu* (A study of the history of Christianity in Japan). Tokyo: Unebi Shobo, 1942.

Ebisawa, Arimichi. *Namban Bunka* (Namban culture). Tokyo: Shibundo, 1958.

Ebisawa, Arimichi. *Nihon Kirishitan Shi* (A history of Christians in Japan). Tokyo: Hanawa Shobo, 1966.

Ikenaga Hajime. *Hosai Banka Daihokan* (Collection of Namban paintings executed in Japanese pigments). Osaka: Sogensha, 1933.

Kuga, Ichio. *Kirishitan Amakusa Toban no Kenkyu* (A study of Christian publications in Amakusa). Osaka: Sojinsha, 1963.

Kuga, Ichio. *Nihon Shoki Yofuga to Kalydonian no Inoshishigari* (Early Western-style painting and "The Calydonian Boar Hunt"). Osaka: Sojinsha, 1968.

Matsuda, Kiichi. *Kinsei Shoki Nihon Kankei, Namban Shiryo no Kenkyu* (A study of international relations and Namban material during the early Edo period). Tokyo: Kazama Shobo, 1967.

Matsuda, Kiichi. *Kirishitan : Shijitsu to Bijutsu* (Christians in Japan: Historical background to their art). Kyoto: Tankosha, 1969.

Matsuda, Kiichi. *Namban Shiryo no Hakken* (The discovery of Namban materials). Tokyo: Chuo Koronsha, 1964.

Matsuda, Kiichi. *Nichio Kosho Shi Bunken Mokuroku* (A history of Japanese-European relations; a bibliography). Tokyo: Isseido, 1965.

Matsuda, Kiichi. *Nippo Kosho Shi* (A history of Japanese-Portuguese relations). Tokyo: Kyobunkan, 1963.

Matsuda, Kiichi. *Taiko to Gaiko; Hideyoshi Bannen no Fubo* (Toyotomi Hideyoshi and his diplomatic policy; a profile of Hideyoshi in his last years). Tokyo: Togensha, 1966.

Matsuda, Kiichi. *Tensho Shonen Shisetu* (The mission of

four young Japanese nobles to Europe in the Tensho era).
Tokyo: Kadokawa Shoten, 1965.

Nagami, Tokutaro, ed. *Namban Bijitsu* (Namban art).
Kyoto: Taigado, 1943.

Nagami, Tokutaro. *Namban Byobu Taisei* (A complete
collection of the Namban screens). Tokyo: Kogeisha, 1930.

Nagayama, Tokihide. *Kirishitan Shiryo Shu* (A collection
of historical materials relating to the Roman Catholic relig-
ion in Japan). Nagasaki: Taigai Shiryo Hokan Kankokai.

Nishimura, Tei. *Kirishitan to Chado* (Christians and the
tea ceremony). Kyoto: Zenkoku Shobo, 1948.

Nishimura, Tei. *Namban Bijutsu* (Namban art). Tokyo:
Kodansha, 1958.

Nishimura, Tei. *Nihon Shoki Yoga no Kenkyu* (A study in
early Western-style paintings in Japan). Kyoto: Zenkoku
Shobo, 1945.

Okada, Akio. *Kirishitan: Bateren* (Christians and padres).
Tokyo: Shibundo, 1955.

Okada, Akio. *Namban Shidan* (Namban episodes). Tokyo:
Jimbutsu Oraisha, 1967.

Okada, Akio. *Namban Shuzoku Ko* (Reflections on Nam-
ban religious customs). Tokyo: Chijinshokan, 1942.

Okamoto, Yoshitomo. *Juroku Seiki Nichio Kotsu Shi no
Kenkyu* (A study in the history of Japanese-European re-
lations in the sixteenth century). Tokyo: Kobunso, 1936.

Okamoto, Yoshitomo. *Kirishitan Yoga Shi Josetsu* (An in-
troductory essay on the history of Western-style Christian
paintings in Japan). Tokyo: Shorinsha, 1953.

Okamoto, Yoshitomo. *Momoyama Jidai no Kirisuto Kyo
Bunka* (Christian culture in the Momoyama period).
Tokyo: Toyodo, 1949.

Okamoto, Yoshitomo. *Namban Bijutsu* (Namban art).
Nihon no Bijutsu (Japanese art), vol. 19. Tokyo: Heibon-
sha, 1965.

Okamoto, Yoshitomo. *Namban Byobu Ko* (Reflections on
Namban screens). Tokyo: Shorinsha, 1958.

Okamoto, Yoshitomo, and Takamizawa, Tadao. *Namban
Byobu* (Namban screens). Tokyo: Kashima Kenkyujo
Shuppankai, 1970.

Sakamoto, Mitsuru, *et al. Namban Bijutsu to Yofuga*
(Namban art and Western-style paintings). *Genshoku
Nihon no Bijutsu* (Japanese art in color), vol. 25. Tokyo:
Shogakkan, 1970.

Seki, Mamoru, *Seiiki Namban Bijutsu Tozan Shi* (A his-
tory of the progress of Namban art from West to East).
Tokyo: Kensetsusha, 1933.

Shinmura, Izuru. *Namban Hen (kan)* (On Namban; Part
A). *Shinmura Izuru Senshu* (The collected works of Shin-
mura Izuru), vol. 1. Kyoto: Kocho Shorin, 1943.

Shinmura, Izuru. *Namban Hen (kon)* (On Namban; Part
B). *Shinmura Izuru Senshu* (The collected works of Shin-
mura Izuru), vol. 2. Kyoto: Yotokusha, 1945.

Kobe Shiritsu Namban Bijutsukan Zuroku Dai 1-Kan
(Catalogue of Namban Art, vol. 1, Kobe City Museum of
Namban Art). Kobe: Kobe City Museum of Namban Art,
1968.

Cover Illustration: Catalogue No. 11. *Namban Screens* by Kano Naizen (detail).
Catalogue produced by the Meriden Gravure Company
Catalogue design by Kiyoshi Kanai, New York
Photography by Nissha Printing Company, Ltd., Kyoto
Translation by Hiroaki Sato, New York